# JOHN EVERETT MILLAIS

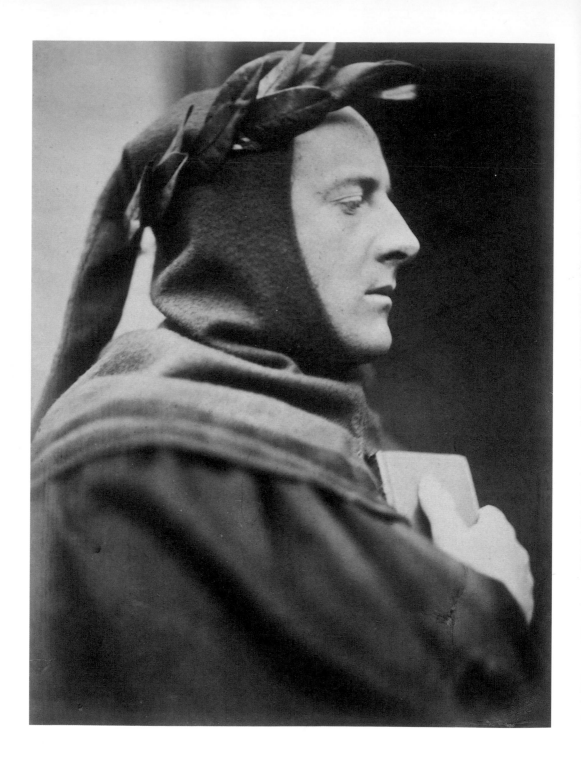

# JOHN EVERETT MILLAIS

Christine Riding

British Artists

Tate Publishing

## For John and Patricia Riding

*Acknowledgements*

I would like to thank my Tate colleagues Robin Hamlyn, Alison Smith and Ben Tufnell, and Peter Trippi, Director of the Dahesh Art Gallery, for their advice and support. A particular debt of gratitude must go to Debra Mancoff, whose insightful comments have undoubtedly made this a better book. And also to my sister Jacqueline Riding who has read the text on numerous occasions. My thanks also go to Richard Humphreys and Nicola Bion, whose patience and good humour have been greatly appreciated. And to Alice Chasey who took over from Nicola as project editor and Mary Scott for her careful copy-editing. Thanks also to Sally Nicholls and Sophie Lawrence.

Also available in this series:

*Francis Bacon* Andrew Brighton
*William Blake* William Vaughan
*Edward Burne-Jones* David Peters Corbett
*John Constable* William Vaughan
*Jacob Epstein* Richard Cork
*Henry Fuseli* Martin Myrone
*Thomas Gainsborough* Martin Postle
*William Hogarth* Matthew Craske
*Gwen John* Alicia Foster
*Wyndham Lewis* Richard Humphreys
*Paul Nash* David Boyd Haycock
*Samuel Palmer* Timothy Wilcox
*Dante Gabriel Rossetti* Lisa Tickner
*Walter Sickert* David Peters Corbett
*Stanley Spencer* Kitty Hauser
*George Stubbs* Martin Myrone
*J.M.W. Turner* Sam Smiles
*James McNeill Whistler* Robin Spencer
*Joseph Wright* Stephen Daniels

General Editor: Richard Humphreys,
Senior Curator, Tate Britain

First published 2006 by order of
the Tate Trustees
by Tate Publishing, a division of
Tate Enterprises Ltd,
Millbank, London SW1P 4RG
www.tate.org.uk/publishing

British Library Cataloguing in Publication Data
A catalogue record for this book is available from the British Library

ISBN 10: 1 85437 523 7
ISBN 13: 9781 854 375230

Distributed in North America by
Harry N. Abrams, Inc., New York
Library of Congress Control Number:
2004 111 332

Concept design James Shurmer
Book design Caroline Johnston
Printed in Hong Kong by South Sea
International Press Ltd

Front cover: John Everett Millais
*Ophelia* 1851–2 (detail, fig.9)
Back cover: John Everett Millais
*The Black Brunswicker* 1859–60 (fig.29)
Frontispiece: David Wilkie Wynfield
*Sir John Everett Millais as Dante* 1860s
Albumen print 21 × 16.2 (8¼ × 6⅜)
National Portrait Gallery, London

Measurements of artworks are given in centimetres, height before width, followed by inches in brackets

# CONTENTS

# INTRODUCTION

> Why do we cast our pearls before swine? The best we give the
> English public they abuse; the vulgarest they accept and applaud.

These angry words from John Everett Millais (1829–1896) were recorded
by fellow artist, William Blake Richmond, in 1899. According to Richmond,
Millais's indignation was provoked by the poor reception of his paintings on
exhibition at the Royal Academy, which occurred only a few years before his
death in 1896. Richmond deduced, however, that the artist's disaffection was
momentary, given that Millais had a 'high regard for public opinion, and
believed, as many of us do not believe, that public opinion in the matter of Art
is right'.[1]

While these two comments clearly contradict each other, they nonetheless
underline that Millais was deeply concerned with 'public opinion'. In the late
nineteenth century, the Royal Academy was the oldest and generally held to
be the most prestigious of a growing number of public forums through which
an ever-expanding and varied urban and suburban audience came into direct
contact with contemporary art. This broader interest was encouraged and
sustained by rapidly developing international media, in the form of reproduc-
tions, which could be purchased as individual images or in illustrated books
and art-focused publications, such as the mainstream *Magazine of Art*. In
part, these developments underlined an increasingly celebratory impulse and
nationalistic agenda towards British art, whether modern or historic. But they
were also tied into a growing consumer culture promoted by art dealers and a
burgeoning advertising industry, and the rise of the specialist art critic. In this
more 'democratic' art world, a larger proportion of the British public had a
practical and intellectual stake in (and thus potential influence on) contem-
porary art than was patently the case in the late 1840s, when Millais was a
student at the Royal Academy Schools.

Millais self-consciously conducted his career in the public eye and continu-
ally engaged with, exploited and even pandered to the cultural developments
described above. And while 'success' as a term is open to interpretation and
qualification, he was without doubt one of the most successful, as well as
celebrated, British painters of the nineteenth century. Indeed by the 1880s
Millais as a personality was arguably as important as his art. What kind of
personality was he? He was ambitious, self-assured, even arrogant, as well as
candid and sincere. Numerous contemporary commentators noted his easy
charm and humour, and his tall, handsome figure. An early portrait by his
fellow Pre-Raphaelite Brother, William Holman Hunt, shows intelligence and
sensitivity, characteristics that are repeated in a number of extant images of
Millais, by himself and others (fig.1). As a painter, Millais displayed a remark-
able technical facility and adaptability, ranging from the hard-edge realism of

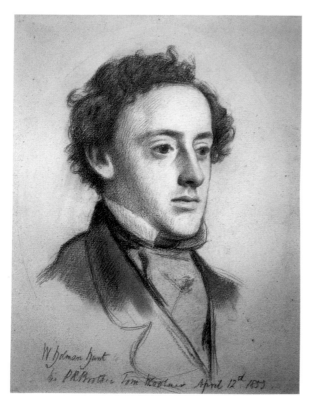

his Pre-Raphaelite period to the 'instinctive naturalism' characteristic of some of his later works. While the stylistic appearance of his paintings changed dramatically, however, they invariably corresponded to Millais's imaginative and poetic temperament and his penchant for mood, pathos and understatement. These qualities were demonstrated within a wide range of subjects and genres, from portraiture, religious works, historical genre to modern-life subjects, book illustration and landscape.

When reading through descriptions of Millais, it becomes clear that the construction of his public profile and posthumous reputation had much to do with the broader opinions, prejudices and allegiances of the individual commentators and art critics (Millais himself made very few published statements concerning his career or artistic credo). Some perceived Millais and his paintings as thoroughly individual, modern and national in character. This was especially true towards the end of the nineteenth century, when enquiries into the essential character of English art and anxieties concerning the influence of foreign (in particular French) painting were prevalent in the art press and periodicals. The art critic and editor of *Magazine of Art*, Marion Harry Spielmann, who knew Millais well, described him in 1896 as 'Anglo-Saxon from skin to core'; that is, 'true, straightforward, honest'.[2] And his early biographer Alfred Lys Baldry wrote on similar lines, characterising Millais as exuding 'manly wholesomeness' without the 'taint of modern decadence or morbidity'.[3] Thus Millais's bluff geniality and plain, unaffected dress – denoting bourgeois respectability and 'traditional' constructions of masculinity – were

contrasted with the perceived effeminacy, eccentricities and exhibitionism of the aesthete and the dandy, associated from the 1860s with Aesthetic Movement artists such as Dante Gabriel Rossetti and the Paris-trained James Abbott McNeill Whistler.

To other commentators, particularly those from the generation after Millais's, the image of the highly regarded Royal Academician and wealthy, society portraitist of his later life was proof enough of his 'selling out' from the promise of his 'rebellious' youth. In 'The Lesson of Millais', published just after the artist's death, Arthur Symons noted: 'In the eulogies ... I have seen only: he was English, and so fond of salmon-fishing.'[4] Symons was the editor of the short-lived *The Savoy* magazine, and was in the circle of Aubrey Beardsley, Oscar Wilde and other 'aesthetes'. That this construction of Millais's character as thoroughly English, conservative and respectable was current in the early twentieth century is clear from Max Beerbohm's series of caricatures entitled *Rossetti and his Circle* (1916–17), within which Millais appears only twice. In the first, entitled *British Stock and Alien Inspiration 1849* (fig.2), Millais, Hunt and county politicians are contrasted with Rossetti and Benjamin Disraeli and their respectively Italian and Jewish backgrounds. And in *A Momentary Vision that once Befell Young Millais* (fig.3), we find the artist stunned at the image of himself in later years, in sporting attire, with Edie Ramage from *Cherry Ripe*, perched on his knee.

Despite the numerous admiring voices, in the twentieth century it has largely been the censure from nineteenth-century commentators that has been utilised by art historians in appraising Millais's career. This is especially true of his post-Pre-Raphaelite period (commonly set at 1860). The resurgence of interest and appreciation in the Brotherhood and Pre-Raphaelitism (and other aspects of Victorian art, such as Aestheticism) from the 1970s has served only to intensify the still widely held view that post-1860, Millais ceased to be vital and innovative. John Ruskin's published attacks in the late 1850s, in which he categorised the artist's move away from Pre-Raphaelitism as 'not merely fall but catastrophe', have been taken as an authoritative and impartial observation, and applied to *anything* that Millais subsequently painted. This is as much a misreading of Ruskin as of Millais. In his preface to the catalogue accompanying Millais's retrospective exhibition at the Grosvenor

Below left
2 Max Beerbohm
*British Stock and Alien Inspiration, 1849* 1917
Pencil and watercolour on paper
29.8 × 41.9
(11¾ × 16½)
Tate

Below right
3 Max Beerbohm
*A Momentary Vision that Once Befell Young Millais* 1916
Pencil and watercolour on paper
32.4 × 43.2
(12¾ × 17)
Tate

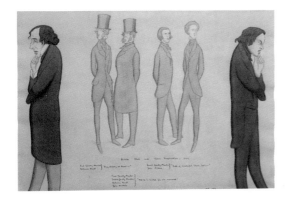
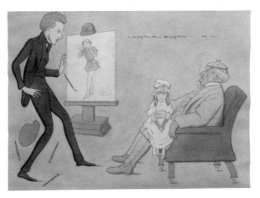

Gallery in London of 1886, Ruskin noted that it was the most important display of English art yet staged, and that his previously published criticisms (printed in the accompanying exhibition catalogue) were made not for eternity but reflected his concerns for British art at specific moments.[5] While this does not negate the broader value of Ruskin's opinions, it underlines the necessity of scrutinising the commentator and the context. This is equally true of William Holman Hunt's *Pre-Raphaelitism and the Pre-Raphaelite Brotherhood* (1905), which was published after both Millais and Rossetti were dead. Hunt's publication is, in fact, an autobiography and disingenuously appropriates most of the credit for the formation and inspiration of the Brotherhood and significantly downplays Rossetti's participation. His appraisal of Millais (who was a lifelong friend) was that he was a talented painter but not an intellectual, who had the wit to pick up on Hunt's excellent ideas, and whose idiosyncratic brand of 'genius' was merely a series of flashes that occasionally gripped Millais from 'he knew not where'. Such opinions have been generally accepted as reliable, if not factual. Indeed those contemporary commentators who questioned or condemned Millais's 'success' and popularity during his lifetime have chimed with twentieth-century notions of artistic integrity and vitality, which necessarily meant isolation from and confrontation with the art establishment (above all represented by the Royal Academy) and public taste. Arguably Rossetti has fared better than Millais in more recent art criticism *because* of his outré lifestyle and, as Arthur Symons wrote in 1896, because he had 'cloistered his canvases in contempt of the multitude and its prying unwisdom', while Millais 'deliberately abandoned a career which, with labour, might have made him the greatest painter of his age, in order to become, with ease, the richest and the most popular'.[6]

This is the standard account of Millais during the entire twentieth century. Alan Bowness wrote a damning assessment in the Tate Gallery's *The Pre-Raphaelites* exhibition catalogue (1984). 'Millais's own later work,' noted Bowness, 'is disappointing. Lovely passages of paint, but such vacuity behind the conception. Without the support and stimulus of his Pre-Raphaelite brethren, Millais seems sadly lost.'[7] Such judgments have been examined and challenged by art historians Malcolm Warner, Anne Helmreich, Paul Barlow and others. Barlow in particular reads 'throw-away' comments, such as those by Bowness, as part of the modernist critical tradition that 'sees all forms of modern art as emerging from the French Impressionist and Realist schools, with Manet as the talismanic representative of avant-garde authenticity'.[8] Even Millais's brief moment of avant-gardism (that is, the deliberately confrontational agenda of the Pre-Raphaelite Brotherhood) does not sit easily within this trajectory in view of the formal qualities of Pre-Raphaelite art.

While scholarly research on Millais's life and work is undoubtedly entering a new, dynamic phase, the question still remains, 'How did Millais view himself?' His self-portrait of 1880 (fig.4) was executed for the Uffizi's celebrated collection of self-portraits, an important context for any artist's notion of self. The portrait presents a gentlemanly, working artist, who is plainly dressed, with brush and palette in hand. The expression is sensitive, with the face in half-shadow. The dashes of white paint on the collar, handkerchief and

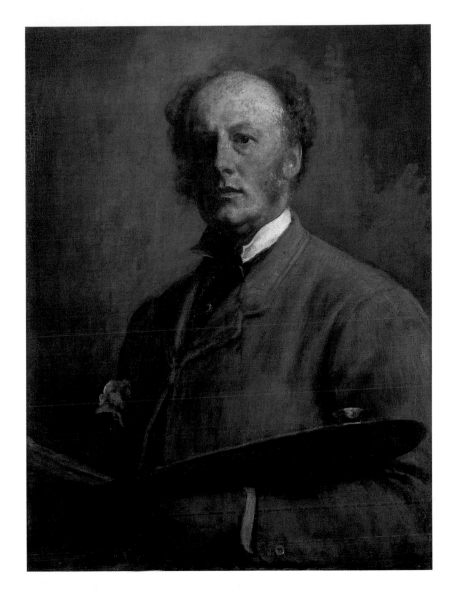

4 *Self-Portrait* 1880
Oil on canvas
86 × 65
(33⅞ × 35⅝)
Uffizi Gallery,
Florence

palette edge form lively accents within a predominantly brown-toned compo-
sition. Is this the portrait (to quote Russell Ash) of a 'conservative ... success-
ful businessman'?[9] Ash's comment, I would argue, misinterprets Millais's
artistic intentions. Indeed, this portrait – by an artist who, in 1880, was one of
the richest men in Britain – focuses not on outward signs of material success
or bourgeois respectability, but artistic achievement, measured through the
direct referencing of Old Master self-portraiture, specifically that of Rem-
brandt, whom Millais admired at this time. Within 'Thoughts on Our Art of
To-day', first published in *Magazine of Art* (1885), Millais made a thinly veiled
analogy between the Old Master's career and his own. Thus Rembrandt's
early work was 'very careful and minute in detail'. But as he came to 'the full-
ness of his power, all appearance of such manipulation and minuteness van-
ished in the breadth and facility of his brush'.[10] In Rembrandt's *Self-Portrait*

*with Two Circles* 1665–9, the artist stands, paintbrushes in hand, face in half-shadow. The colour palette is similarly tonal, browns and blacks with accents of white. Clearly Millais did not view *himself* as a successful businessman. His ambitions as a painter were much higher. He sought to make parallels between his own artistic achievements and status and those of the Old Masters.

## Biography

Millais was born in Southampton on 8 June 1829. His father, John William, was a moderately wealthy man, whose family originated from Jersey. With his parents' support, Millais began his artistic training from an early age, coming to London in 1838 and entering the Royal Academy School in 1840 as the youngest ever student. With his precocious talent, he quickly became a star pupil, winning medals for drawing in 1843 and for painting in 1847. His first exhibited painting, *Pizarro Seizing the Inca of Peru*, executed in the style of William Etty, was shown at the Royal Academy in 1846. In 1848, he was one of the founding members of the Pre-Raphaelite Brotherhood (PRB), a group of disenchanted young artists and writers whose stated aim was to reform aspects of British art. During his association with the Brotherhood, Millais developed his ability to paint close portraits and to observe character, expression and nature, evident throughout his career. The discovery of the meaning of the PRB monogram sparked suspicions of a secret society and initiated the vicious press campaign of 1850–1, largely directed at Millais's *Christ in the House of His Parents (The Carpenter's Shop)* 1849–50 (fig.8). This resulted in John Ruskin's letters of support for the artists, published in *The Times*. Millais achieved his first critical and popular success in 1852, with *A Huguenot* (the first of almost 100 paintings by Millais to be engraved for the lucrative print market), and was elected Associate Royal Academician in 1853, by which time the Brotherhood had disbanded. In the summer of 1853, Ruskin and Millais holidayed in Scotland, where Millais embarked on his portrait of Ruskin and fell in love with his wife, Effie. The Ruskins' marriage was annulled in 1855 and Millais and Effie were subsequently married. During a forty-year marriage they had eight children.

From 1856, Millais produced a series of paintings that were poetic, non-narrative and relatively loosely painted, beginning with *Autumn Leaves* 1855–6. These works largely eschewed Pre-Raphaelitism in its earliest manifestation, but can be said to have heralded its second phase from 1857, led by Rossetti. The paintings proved difficult to sell and caused negative press campaigns in 1857 and 1859, influenced by Ruskin's now hostile opinions. Millais had already begun a highly successful career in book illustration, which, during the financially difficult years of the late 1850s, was an important source of income and through which he achieved celebrity. Between 1855 and 1864, he produced a large number of designs including those for Edward Moxon's *Poems by Alfred Tennyson* (1857), which pioneered the revival of black and white illustration, for *Once A Week* magazine (from 1859), *Cornhill Magazine* (1860–1, 1862–4), an illustrated publication of Anthony Trollope's *Orley*

*Farm* (1861–2) and 'The Parables of Our Lord' in *Good Works* (1863), printed in a separate volume in 1864. A large number of Millais's periodical illustrations were reprinted in a total of three book collections during his lifetime.

In 1863, Millais exhibited *My First Sermon* (fig.35), a painting which, like *The Black Brunswicker* 1859–60 (fig.29), was calculated to be popular with critics, dealers, collectors and the public, and coincided with Millais's election as a Royal Academician. Far from 'selling out' to popular taste, however, Millais participated during the 1860s in the Aesthetic Movement. This is characterised today as a movement of progressive artists, such as Rossetti, Whistler and Albert Moore, and one that was influenced by Millais's earlier paintings such as *Autumn Leaves*. He was also instrumental in the revival of interest in eighteenth-century fine and decorative art, promoted by numerous exhibitions in London and elsewhere and, as with artists such as Whistler and Édouard Manet, engaged with the growing interest in seventeenth-century Spanish art, in particular Diego Velázquez. Millais's diploma painting of 1868, entitled *A Souvenir of Velázquez* (fig.41), signalled his artistic ambitions within an Old Master context, and exemplified the child portraiture and fanciful pictures, reminiscent of Joshua Reynolds, for which he was becoming increasingly renowned. In this, Millais was also exploiting the nostalgia during the second half of the nineteenth century for a pre-Industrial, rural and aristocratic society, which British art of the eighteenth century was thought to represent.

By 1870 Millais had identified a niche for himself as a portraitist, to which he brought his formidable talent for capturing likenesses, his technical facility and his singular notion of how to imbue the image with authority. This was largely achieved through the subtle referencing of Old Masters and an overall strategy of dignified understatement. (Millais painted four British prime ministers, a unique achievement in the nineteenth century.) Parallels in strategy can be found in the work of other successful portraitists, such as Frank Holl and Hubert von Herkomer, but Millais's approach contrasted with the glittering flamboyance of James Tissot, James Sant and, towards the end of Millais's career, John Singer Sargent. In 1878, Millais moved into a grand, purpose-built studio house in South Kensington, a highly visual testimony to his wealth, in response to which the historian and social commentator Thomas Carlyle reputedly said in astonishment, 'Has a paint pot done all this?' In 1885, he was created a baronet.

Despite his highly lucrative portrait practice, Millais continued to produce a wide range of painting genres, including religious and historical subjects and contemporary social commentary, all of which are subtly dramatised. From 1870 to 1892, Millais executed a series of unconventional large-scale landscapes, to which, as with other areas of his work, he sought to bring a sense of poetry and emotional, even spiritual, significance. In 1890, he exhibited *Dew-Drenched Furze* (fig.53), a mystical, visionary landscape. After the death of Frederic Leighton in January 1896, Millais briefly became President of the Royal Academy. He died six months later.

# 1

# BROTHERS IN ART

## The Pre-Raphaelite Brother

In 1848, Millais and William Holman Hunt submitted two paintings to the Royal Academy's Selection Committee. The subject of Millais's *Cymon and Iphigenia* (fig.5) was taken from Boccaccio's *Decameron* and that of Hunt's *The Flight of Madeline and Porphyro* from a poem by John Keats *The Eve of St Agnes*. Both artists had chosen love themes: Hunt, the triumph of young love in the face of a hostile world and Millais, the transformative power of love, which converts the hero from an uncouth dullard into a sophisticated gallant. Millais had taken as his model the history painter, William Etty. A well-respected Royal Academician, Etty was identified primarily with nude paintings and the brushwork and vibrant colour traditionally associated with the Venetian school and Rubens. Unlike the idealised nude of classical tradition, Etty's figures were sensuous and pleasing. Millais emphasised these characteristics by painting a scene akin to a bacchanalian revel, with a coquettish Iphigenia taking a sideward glance at the oafish Cymon. In a very different mood, Hunt's painting emulated the high-minded painting style then being employed for Arthurian and chivalric subjects at the new Palace of Westminster by the established artists William Dyce and Daniel Maclise. Such art had its roots in the Gothic Revival and Romantic medievalism of the early nineteenth century and in particular the archaism developed by a group of German artists known as the Nazarenes. In terms of reforming zeal and organisation, the Nazarenes were precursors of the Pre-Raphaelite Brotherhood.

The young artists had chosen two strands of contemporary British art, carried forward from the Romantic period and endorsed at the highest levels of the art establishment. Millais's painting was rejected. Hunt later recorded that the reason given was its unfinished state. Technically speaking, the painting is extremely skilful – slick even – for an artist aged just eighteen. But it hovers between pastiche and parody. Perhaps it was this that persuaded Royal Academy members to teach their star pupil a lesson. They must have been astonished by the transformation from *Cymon and Iphigenia* to *Isabella*, accepted for exhibition the following year (fig.6). The significant factor in the twelve months that separate these two paintings was the formation of the Pre-Raphaelite Brotherhood, traditionally dated to September 1848. Much time and energy has been expended by commentators and scholars in establishing who was most significant in shaping the Brotherhood and Pre-Raphaelitism. This is particularly true of the PRB's three main members, Hunt, Millais and Rossetti. For Hunt, the most significant relationship, developed from as early as 1844, was between himself and Millais. As he later recorded, they were

Opposite above
5 *Cymon and Iphigenia* 1848
Oil on canvas
147.3 × 114.3
(58 × 45)
National Museums of Liverpool, Lady Lever Art Gallery

Opposite
6 *Isabella* 1849
Oil on canvas
109.9 × 142
(40 × 56)
National Museums of Liverpool, Walker Art Gallery

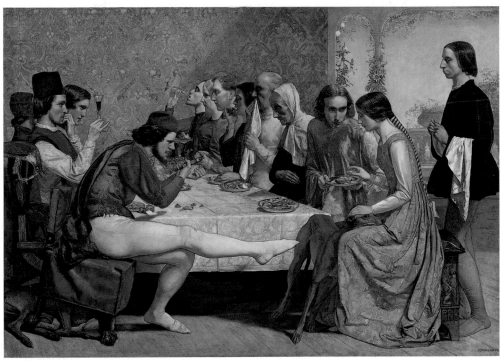

working together during 1847–8, discussing the deplorable state of British art and the need for reform. The true balance of power is impossible to determine and most likely an unhelpful diversion.

Millais's and Hunt's early relationship was emblematic of a more general desire among budding artists for mentors and peer-group collaborators, within an art world where formal training schools – that of the Royal Academy being the most prestigious – were incapable of meeting demand for student places or tuition. Clearly the PRBs were all very different characters. Millais was first and foremost a painter, the most naturally talented among the Brothers, with a poetical sensibility, but he had neither the literary background or ambitions of Rossetti, nor his predilection for exclusive societies. Hunt was evangelical in temperament, and his sense of personal mission quickly developed into a singular artistic style denoted by its symbolic realism. But the word that defines the relationship between these young men is collaboration. This has been the argument recently expounded by Elizabeth Prettejohn, who states that their combined 'endeavours in poetry and critical writing, as well as in the visual arts' and 'collaborative working practices', produced 'an output that was even more important than the individual input of its members'.[1] Unlike Rossetti, neither Millais nor Hunt would experience anything like it again.

What distinguished the members of the Brotherhood from their contemporaries was their strong sense of group identity, exemplified by Millais's use of the PRB monogram in *Isabella*. Indeed it was the discovery of what PRB stood for that provoked the anti-Pre-Raphaelite press campaign in 1850, critics suspecting an organised artistic revolt, rather than a quirky form of revivalism. The Brotherhood certainly formulated a stylistic strategy, which the painters in the group adhered to. And they discussed art matters, made suggestions, sat for each other and contributed in varying degrees to the Brotherhood's short-lived journal *The Germ*. None of the Brothers lost their individuality, which is clear from the way their painting styles developed within the parameters they had set out together. As *Cymon and Iphigenia* demonstrated, Millais was adept at assimilating ideas and improvising styles, as would be expected from a talented student. His extraordinary drawing, *The Disentombment of Queen Matilda* 1849, demonstrates the Gothic/Catholic tendency of the earliest Pre-Raphaelite style and subject matter, but is far more severe and exaggerated than anything produced by the others. Thus Millais's works from 1849–50 are both singular and representative of Pre-Raphaelitism in its earliest manifestation.

Millais's portrait of *Mrs James Wyatt and her Daughter, Sarah* 1850 (fig.7) has been justly described as a Pre-Raphaelite manifesto. Millais juxtaposed the sitters, stiffly posed, with prints after Leonardo da Vinci's *Last Supper*, flanked by Raphael's *Madonna della Sedia* and *Alba Madonna*. The use of the term 'Pre-Raphaelite' was to indicate that the PRB's inspiration came from painting before the High Renaissance (approximately pre-1500). Such art was designated as 'primitive' in comparison to the graceful, idealising formal language employed by later artists and which prevailed into the 1840s, as demonstrated by *Cymon and Iphigenia*. In the mid-nineteenth century, Raphael was still

7  *Mrs James Wyatt
and her Daughter
Sarah c.*1850
Oil on wood
35.3 × 45.7
(14 × 18)
Tate

considered the most exemplary of High Renaissance painters and was pro-
moted as such to students at the Royal Academy. Thus to be 'Pre-Raphaelite'
was confrontational. Millais gives this artistic expression by contrasting
Raphael's two representations of the Madonna and Child with the sober rigid-
ity of Eliza Wyatt and her daughter, not only juxtaposing idealised and mod-
ern motherhood, but presenting a confrontation of styles within the painting.
It may also represent a subtle dig at the celebrated portrait of Caroline
Duchess of Marlborough and her daughter (1764–7) by the revered Sir Joshua
Reynolds, founding President of the Royal Academy, or Sir 'Sloshua' as he was
dubbed by the Brothers, because of his 'Raphaelite' paintings. The Wyatt por-
trait makes clear, however, that while the rallying point was art before 1500, it
was not slavishly copied by the Brothers. Indeed it is debatable how far Pre-
Raphaelite art was actually 'pre-Raphael'. The portrait has a look of both
early Flemish portraiture and the religious art of Giotto and Cimabue. But Mrs
Wyatt is clearly a woman of her own time. It is in refusing to idealise and flat-
ter that the portrait challenges Raphaelite art.

These anti-idealising characteristics had been explored previously in
Millais's *Isabella*. The subject is taken from a poem by Keats, *Isabella; or, The
Pot of Basil*, itself based on a story by Boccaccio. *Cymon and Iphigenia* and
*Isabella* share a literary source and a composition that is multi-figured and
complex. But the similarities end there. With *Isabella*, gone is the bland, pretti-
ness, the vacuous sensuality, the melting colours and brushwork, the flaccid
figuration and the hierarchy of detail, receding from foreground to back-
ground, of *Cymon and Iphigenia*. In contrast, the viewer is struck by the atten-
tion to detail, the way the scene appears to have been floodlit, the manner in
which the figures are banked awkwardly in their seats and the overwhelming
sense that everyone around the table is an actual person. Indeed, most of
them are precise portraits of Millais's Brothers, associates and family mem-
bers. But what appears at first glance to be an insignificant event is psycho-
logically charged, indicating the tragic events of the future. This is achieved
through the proliferation of representative objects such as passionflowers and
pieces of blood orange, harbingers of passion and violence, and the gestures
and expressions of the four seated figures in the foreground; on the right, the

secret lovers Lorenzo and Isabella and, on the left, her brothers. Lorenzo is in their employ. On discovering the relationship, they murder him. Lorenzo's intense look, emphasised by the shadow over his eyes, is avoided by Isabella. But her true feelings are denoted by the tenderness of her hand resting on the greyhound's head. One brother, ostensibly looking at a glass of wine, sees the look and begins to suspect. The other brother, his face contorted with aggression, makes a kick at the dog, a signal of his brutal nature and the violence to come.

All these elements were developed further in Millais's first religious painting, *Christ in the House of His Parents* (fig.8). Of the Pre-Raphaelite works on exhibition in 1850, it was this painting that was the focus of the furore, taken by critics as representative of the whole PRB and its aims. *Isabella* had been moderately well received by the press. What was different? Whereas the composition of *Isabella* is wilfully asymmetrical, here the figures and surroundings form a symmetrical pattern. This creates a sense of otherworldliness and ritual in a scene that is otherwise mundane and oppressively detailed, from the wood shavings on the floor, the carpentry tools hanging on the back wall, the pale eyelashes and dirty toenails of the boy and the furrowed brow of his mother, to the bulging veins and sunburnt forearms of his father. But this is no ordinary family. The press, stoked up by the idea of an artistic conspiracy, reacted ferociously to what they viewed as a repulsive, near blasphemous representation of the Holy Family. Millais would have realised how confrontational this painting was, a radical departure from the idealised, Raphaelite treatment associated with this subject. Indeed the focus within published criticisms on disease and deformity and phrases like 'loathsome reality' and 'putridity', most famously expounded by Charles Dickens in *Household Words*

8  *Christ in the House of His Parents (The Carpenter's Shop)* 1849–50
Oil on canvas
86.4 × 139.7
(34 × 55)
Tate

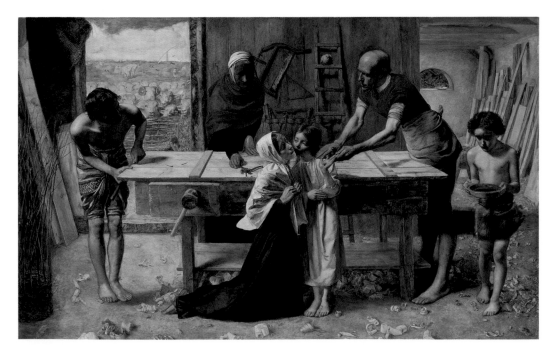

(1850–9), underlines the general critical conclusion that Millais had taken Pre-Raphaelite realism too far. The reaction may have been additionally coloured by the religious implications of the scene with its High Church, or Tractarian, symbolism. The PRBs were, at this time, influenced by Tractarianism, also known as the 'Oxford Movement', which sought to reintroduce aspects of Catholicism into the Anglican Church.

In 1851, Millais retreated from such overt provocation in submitting *The Return of the Dove to the Ark* (a less contentious religious subject) with *The Woodman's Daughter* and *Mariana*. But the anti-PRB press campaign continued. Unlike Rossetti, Millais and Hunt were determined to exhibit at the Academy. It was there that the critical battles were fought and where there was both opposition and support from the Academicians themselves. In 1851, Millais solicited the help of John Ruskin, through his friend and early patron, the poet Coventry Patmore. Ruskin was not only the most influential art critic in England, but was amongst a new breed of wealthy middle-class collectors who supported contemporary British art. Thus Ruskin had a dual role and, by extension, power as both a commentator and a patron. Ruskin's crucial intervention, through two letters published in *The Times*, provided the link between his views expounded in the first volume of *Modern Painters* of 1843 (a work that Hunt greatly admired) and the aims of the PRB, and began a process of reassessment by hostile critics and hesitant collectors. His book also provided art history with the oft-quoted maxim of Pre-Raphaelitism, 'Truth to Nature'. In *Modern Painters*, Ruskin had called on the 'young Artists of England' to 'go to nature in all singleness of heart ... rejecting nothing, selecting nothing, and scorning nothing'.[2] In his opinion, the PRBs had done precisely that.

## Ophelia

If 'Truth to Nature' has become the motto of Pre-Raphaelitism, Millais's *Ophelia* 1851–2 (fig.9) is considered by many to be its paradigm. The subject is taken from Act IV of *Hamlet*, when Queen Gertrude announces Ophelia's death – drowned in 'the glassy stream' – which happens offstage. Ophelia has been driven to madness after the murder of her father by her lover Hamlet, who has also cruelly spurned her. Millais spent up to eleven hours a day, during July to October 1851, painting at the Hogsmill River, near Ewell in Surrey. There he observed closely the forms and condition of the water, trees and plants. For example, the reeds on the left are fresh, damaged or dead and, at their base, blades of floating grass are caught, denoting the gentle flow of the stream. The composition thus combines the particularities of a rural location and Shakespeare's text. The flowers are those that were growing on the river bank and those described by Gertrude or mentioned previously by Ophelia and her brother Laertes. Others were added for their symbolic value. The poppy near Ophelia's right hand symbolises both sleep and death, often jointly referenced in *Hamlet*, as demonstrated by some of its most famous lines, 'To die, to sleep,/ To sleep, perchance to dream'.

From the Romantic period onwards, *Hamlet* was thought by many to be the greatest of Shakespeare's sublime dramas. Thus depicting a scene from

*Hamlet* was not unusual. Showing Ophelia about to drown, however, was. Indeed, it is remarkable how far Millais departed from conventional wisdom in his interpretation. Throughout the nineteenth century Ophelia was a favoured literary figure and preferred Shakespearean heroine for British artists. Richard Redgrave had exhibited a version of Ophelia seated at a river bank in 1842; in 1852, Arthur Hughes, a member of the growing Pre-Raphaelite circle, exhibited a painting showing the same moment. There was a tendency at this time to depict actual Shakespearean productions or representations that were suggestive of the theatre. Maclise's *Play Scene from Hamlet*, exhibited at the Royal Academy in 1842, retains the atmosphere of the play within a play and emphasises the *Stürm und Drang* of the moment with overblown theatrical gesturing and expressions.

The supernatural/magical plays, such as *A Midsummer Night's Dream* and *The Tempest*, encouraged the conflation of Shakespearean subjects with the popular fairy subject-paintings, for example, Joseph Paton's *Reconciliation of Oberon and Titania* (Royal Society of Arts 1847). Millais's *Ferdinand and Ariel* (RA 1851), inspired by *The Tempest*, displays both fantasy and artificiality, while paradoxically demonstrating Pre-Raphaelite formal principles and being set in the open air. Similarly Hughes emphasised the allusions made in Shakespeare's text to Ophelia as a supernatural creature (more specifically a mermaid) as she sinks to her death, characterising her in his painting as a pale, nymph-like creature, perched in the midst of an eerie, unnatural landscape. Uniquely in nineteenth-century art, Eugène Delacroix's three versions of Ophelia at the stream (1838, 1844 and 1853), show her falling awkwardly into the water. Unlike the interpretations by Redgrave and Hughes, in which she is presented as a wronged innocent, Delacroix emphasises that Ophelia has been seduced and abandoned by Hamlet, her figure wrapped in clothing reminiscent of bedsheets. Such an emphasis is wholly in keeping with Shakespeare's original text, but was often edited out of Victorian theatrical productions and even published texts. In a broader context, madness in young women caused by betrayal in love was a common literary, theatrical and operatic theme in the nineteenth century. Millais frequently attended the opera. He certainly saw Vincenzo Bellini's *I Puritani* and perhaps Gaetano Donizetti's *Lucia di Lammermoor*. Both include so-called 'mad scenes'.

In Millais's interpretation, specific theatrical associations are expunged. Instead *Ophelia* exudes an intensified reality, which comes from a refusal to edit and idealise as previously noted in works such as *Isabella*. Millais steers his subject away from the fantastical and prettified or, indeed, the awkward angularity and more lurid colouring of his earliest paintings, to present Ophelia's death to the viewer as an actual event. The specificity of the figure – a real, living woman – is integral to this impression. Millais's oft-noted obedience to Shakespeare's text does not diminish the temporal ambiguity of this event. We know it is Ophelia, but what exactly anchors her to a specific period of history? This ambiguity may derive from a specific collaboration between Millais and Hunt while painting together in Ewell. Hunt was executing the landscape for *The Hireling Shepherd* 1851–2, which is set in the contemporary world. The completed painting shows a shepherd attempting to seduce a shepherdess, her

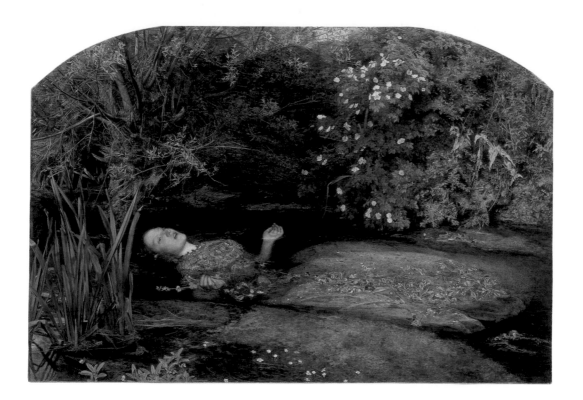

9 *Ophelia* 1851–2
Oil on canvas
76.2 × 111.8
(30 × 44)
Tate

feet dangling over the edge of a stream. A single sheep, straying to the right, presages her fate. Ophelia's death had contemporary resonance given that drowning was by this time associated with 'the fallen woman' who, having sexually transgressed, is abandoned and commits suicide. The third scene of Augustus Egg's trilogy *Past and Present*, exhibited in 1858, suggests as much, with the abandoned wife seated under the arch of a bridge by the Thames, clutching her illegitimate child. G.F. Watts' *Found Drowned* 1848–50 is unusually direct in portraying the body of a young woman lying prostrate under the arch of a bridge, a painting Millais may have known. Later, in 1858, Millais executed an illustration to Thomas Hood's poem *The Bridge of Sighs*, showing a young woman contemplating death on the Thames foreshore. The poem describes the finding of a drowned woman, and calls on the reader to view her fate with compassion rather than contempt.

With its conflation of realism and contemporary associations, Millais's *Ophelia* is far more complex than a faithful illustration to Shakespeare. In comparison to his Pre-Raphaelite Brothers, however, who dealt with sexual transgression in more overt terms (such as Hunt's *The Hireling Shepherd* and *The Awakening Conscience* of 1853, and Rossetti's *Found* of 1853), Millais filtered such social commentary in his paintings through a literary source or attempted to provoke sympathy via a gently poignant interpretation, as can be seen in *The Blind Girl* 1854–6, which engages with the subject of poverty and vagrancy. In this context, *Ophelia* can be viewed as the last in a trilogy of paintings, executed between 1850 and 1852, involving a single female figure. *The Bridesmaid* 1851 (fig.10) shows a young woman passing a piece of wedding

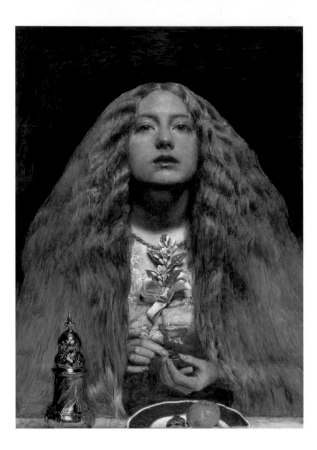

10 *The Bridesmaid*
1851
Oil on canvas
27.9 × 20.3 (11 × 8)
Fitzwilliam Museum,
Cambridge

cake through a ring, legend stating that, if she does so nine times, she will experience a vision of her future lover. Although the orange blossom at her breast denotes chastity, the glazed eyes and parted lips denote desire, the image's sensuousness accentuated by the veil of luxuriant hair, loosened about her shoulders. Painted at approximately the same time, *Mariana* (fig.11) was inspired by Alfred Lord Tennyson's poem of the same title, first published in 1830. The work was exhibited at the Royal Academy in 1851, with the following lines from Tennyson's poem printed in the catalogue:

> She only said, 'My life is dreary,
> He cometh not,' she said;
> She said. 'I am aweary, aweary,
> I would that I were dead!'

The character of Mariana originates from Shakespeare's *Measure for Measure*. She has been in exile for five years, waiting for her fiancé Angelo's return. As the play proceeds she is persuaded to participate in a ruse, posing in the dead of night as the virginal Isabella, whom Angelo desires. Having had sex with Mariana, Angelo is forced to agree to marriage at the close of the play. Thus Mariana's role is ambiguous and ultimately tragic. Millais and Tennyson do not make direct reference to her subsequent fate, the focus of the poem and painting being the relentless passage of time, Angelo's neglect of Mariana and

her suicidal thoughts. In the poem these are signified by the repetition at the end of each stanza of the lines quoted above, and in the painting the stretching pose of Mariana – which, in accentuating her breasts and buttocks can be read as sexual yearning – the scattered leaves on the floor and the near-completed tapestry on the table. But Millais's *Mariana* cannot be described as an illustration of Tennyson's poem in the strictest sense of the word, but rather an imaginative evocation. Only the mouse (bottom right) is mentioned in the text. In fact the tapestry on which Mariana has been labouring for so long is suggestive of Tennyson's *The Lady of Shalott*, first published in 1833 and revised in 1842, in which the eponymous Lady 'weaves by night and day/A magic web with colours gay'. Her moment of revelation comes – 'I am half-sick of shadows' – on seeing 'two young lovers, lately wed'. *Mariana* and *The Lady of Shalott*, shut away in their respective 'prisons', are observers of rather than participators in love and life.

The Bridesmaid, *Mariana* and *Ophelia* thus form a sequence, from the hopeful yearning of an adolescent and the loneliness and sexual frustration of a

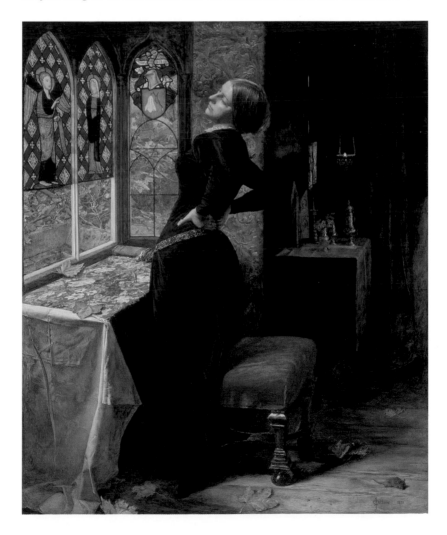

11  *Mariana* 1851
Oil on wood
59.7 × 49.5
(23½ × 19½)
Tate

23

grown woman, to the despair and suicide of a spurned lover. All the women are lost in thought or madness. The individuality and realism of their faces underline that they are portraits of contemporary women, which makes the temporal setting of *Mariana* and *Ophelia* ambiguous. This play on time, context and meaning was to be developed further by Millais in arguably his most experimental work of the late 1850s.

## Millais and Ruskin

Millais and Ruskin became acquainted soon after the critic's published defence of the PRBs. A rapport quickly developed between them. Having accepted the essential value of the PRBs reforms, Ruskin saw an opportunity to introduce a more coherent intellectual agenda. This meant Ruskin guiding the artists towards his singular vision and correcting what he saw as the failings of Pre-Raphaelite art, such as the overwrought detailing and use of High Church symbolism. In the 1850s Ruskin's published writings, above all his *Academy Notes* (1855–9), were formulated with the primary aim of promoting Pre-Raphaelitism, more specifically Ruskinian Pre-Raphaelitism, with its emphasis on landscape. It is, perhaps, not surprising that Ruskin alighted on Millais as his first Pre-Raphaelite protégé. It was not because Millais was more malleable than the others. Even at the height of his involvement with the artist in 1853, Ruskin admitted to his father that 'Millais is a very interesting study but I don't know how to manage him; his mind is so terribly active, so full of invention that he can hardly stay quiet a moment without sketching either ideas or reminiscences'.[3] Amongst the Brotherhood, it was Hunt who held Ruskin in the highest esteem and whose art was consistently sympathet-

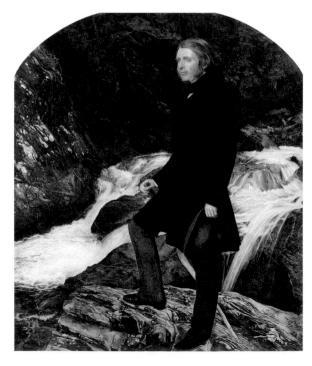

12  *John Ruskin* 1853
Oil on canvas
78.7 × 68
(31 × 26¾)
Private Collection

ic to his ideas. However Ruskin quickly came to regard Millais as the most representative of the Pre-Raphaelite Brothers. In August 1851, Ruskin singled him out for discussion and praise in his influential pamphlet, *Pre-Raphaelitism*.

The purpose of *Pre-Raphaelitism* was to reconcile Ruskin's seemingly dichotomous championship of J.M.W. Turner *and* the PRBs. In this context, by comparing and contrasting Millais with Turner, Ruskin was signalling to his readership that Millais was the key Pre-Raphaelite figure. While Ruskin acknowledged that, as artists, Turner and Millais 'stood at opposite poles', he stated that both had 'defied all false teaching, and ... done justice to the gifts with which they were entrusted'.[4] In the interest of polemics, Ruskin exaggerated differences between them, contrasting Millais's Pre-Raphaelite keenness of vision and lack of invention with Turner's breadth of imagination and feebleness of sight. As demonstration, he compared hypothetically their artistic reaction to mountain scenery. Up to 1851 Millais had not painted such a landscape. But the opening sentences from *Pre-Raphaelitism*, quoted below, anticipates Millais's portrait of Ruskin (fig.12), executed two years later:

> Set them both free in the same field in a mountain valley. One sees
> everything, small and large, with almost the same clearness;
> mountains and grasshoppers alike; the leaves on the branches, the
> veins in the pebbles, the bubbles in the stream ... Meantime, the other
> has been watching the change of the clouds, and the marching of the
> light along the mountain sides; he beholds the entire scene in broad,
> soft masses of true gradation.[5]

In Ruskin's opinion, the two men represented 'culminating points of art in both directions'. And what united them was their sincerity and truth to Nature. In that context they were both 'Pre-Raphaelite'.

Ruskin's admiration for Millais continued to grow. Initially the young artist was grateful for his friendship and support. In 1852, Ruskin's wife, Effie, sat for Millais's *The Order of Release, 1746* (fig.13, exh. RA 1853). The subject is a Highlander, imprisoned after the defeat of the Jacobite army at the Battle of Culloden. The painting shows the moment at which his wife secures his release from gaol. Although four figures are present, three in equal physical prominence, the focus of the painting is the wife's face, modelled by Effie. As with Millais's *A Huguenot*, shown at the Royal Academy the previous year, *The Order of Release* was extremely well received by visitors and critics alike. The *Illustrated London News* noted that Millais had gathered 'a larger crowd of admirers ... than all the Academicians put together'.[6] The RA exhibition of 1853, which also included Millais's *The Proscribed Royalist, 1651* 1853 and Hunt's *Our English Coasts, 1852* 1852 and *Claudio and Isabella* 1850, proved a watershed in the careers of the Pre-Raphaelite Brothers, and Millais's in particular. In January of that year, William Michael Rossetti, the art critic and brother of Dante Gabriel Rossetti noted that 'Our position is greatly altered. We have emerged from reckless abuse to a position of general and high recognition'.[7] Thus, with the undoubted assistance of Ruskin, the PRBs had succeeded in their aim to reform aspects of British art. But the Brotherhood in its initial form was already defunct.

It was during these developments that Millais was engaged with Ruskin's portrait commission, begun during the fateful trip to Glenfinlas in June 1853. Ruskin had originally proposed visiting Switzerland, with the intention of introducing the artist to the kind of mountain scenery he had prescribed in *Pre-Raphaelitism*. Such scenery was significant to Ruskin on two levels: first, he regarded it as a quintessential Turnerian subject and, secondly, he believed that mountains were evidence of the Divine in nature. By switching to a holiday in the Scottish Highlands, Ruskin introduced Millais to a region that would have a lasting impact on his life and art, both as a holiday retreat and as the setting for a number of his contemporary and historical subject-paintings, such as *Autumn Leaves* 1855–6, and his large-scale landscapes from 1870. The Trossachs had been made famous through the writings of Walter Scott, and were part of a more general fashion for the Highlands, carried forward from the Romantic period and popularised by Queen Victoria. Once the idea of a portrait was proposed, Ruskin took the opportunity to supervise Millais in creating a painting that would be the practical expression of his views in *Pre-Raphaelitism*. As with *Ophelia*, Millais painted everything on location but the figure, which was added later. The result is an essay in the minute observation of nature, in particular its geological detailing. While Ruskin was concerned primarily with the landscape, his figure is crucial to the intellectual purpose of the painting, referencing as it does quintessential Romantic images of figures in mountain scenery, contemplating the Divine mysteries of the natural world. Benjamin Robert Haydon's 1842 portrait of William Wordsworth – the supreme Romantic poet of nature, whom Ruskin greatly admired – on Helvellyn may have been in Ruskin's mind. In this sense Millais's painting appropriately combines both the Romantic and Pre-Raphaelite.

The portrait was completed under increasingly strained emotional circumstances. Ruskin, however, continued to applaud Millais's work during the divorce proceedings and after Effie's and Millais's subsequent marriage in 1855. In *Academy Notes*, first published in that year, Ruskin praised *The Rescue* 1855 (fig.14). This was Millais's first completed painting on a subject from contemporary life, and was inspired by an actual event that the artist had witnessed in London earlier in the year. Celebrating the selfless bravery of the fire brigade, Millais focused the action on the stairs of a burning building. A fireman descends with three children, as their mother, kneeling, gratefully receives them. The drama is enhanced by the red glow in the face of one of the children, as he looks upwards towards the fire, cinders floating above and licks of flames on the carpet to the far left. 'It is the only *great* picture exhibited this year,' Ruskin enthused, 'but this is *very* great. The immortal element is in it to the full.' Millais had rushed to finish the painting in time for the exhibition. On this occasion, however, any evidence of haste in the brushwork (and thus not Pre-Raphaelite in Ruskin's eyes) was defended by the critic, on the basis that there was 'a true sympathy between the impetuousness of the execution and the haste of the action'.[8] Ruskin's praise was surpassed in 1856 by his admiration of *Autumn Leaves* (fig.17) and *Peace Concluded, 1856* (referring to the recently concluded Crimean War) both of which he thought 'would rank in future among the world's best masterpieces'.[9] This laudatory tone, however,

13 *The Order of Release 1746* 1852–3
Oil on canvas
102.9 × 73.7
(40½ × 29)
Tate

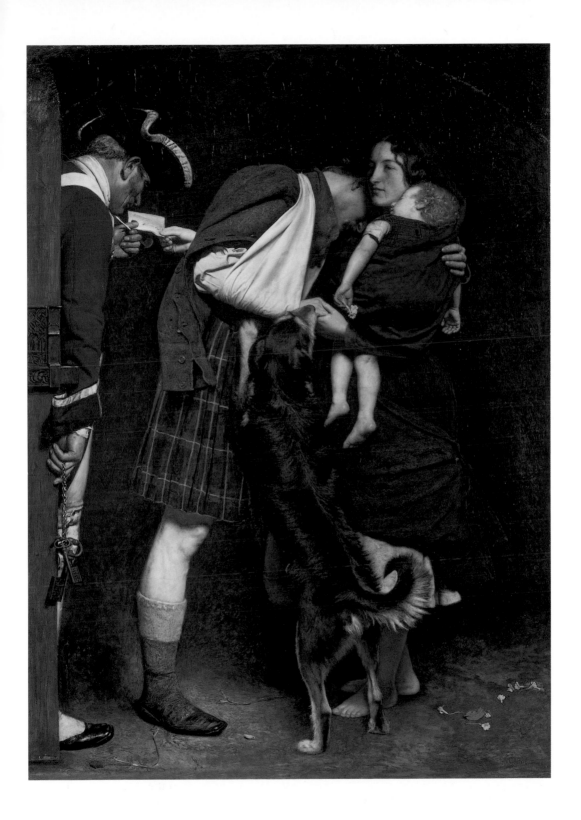

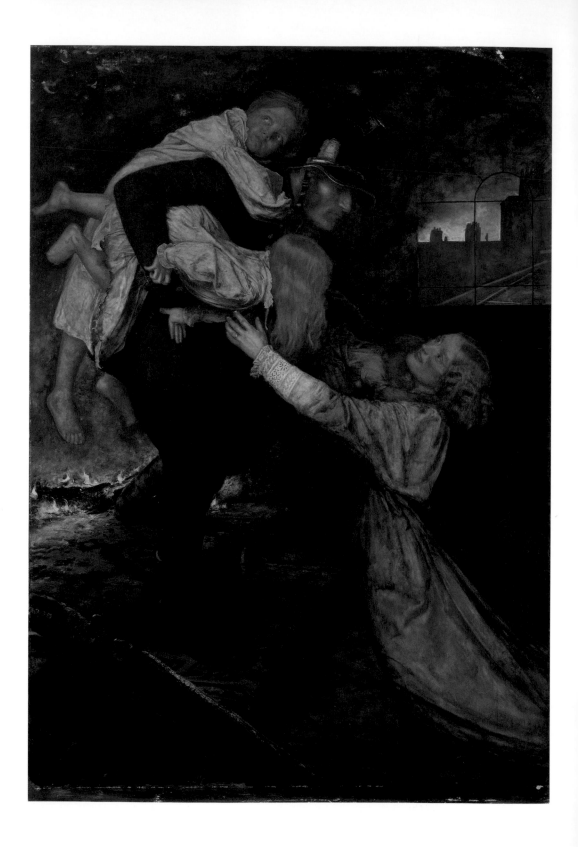

14  *The Rescue* 1855
Oil on canvas
121.5 × 83.6
(47⅞ × 32⅞)
Felton Bequest,
1924. National
Gallery of Victoria,
Melbourne

disappeared the following year. Indeed, *A Dream of the Past: Sir Isumbras at the Ford* (fig.18, p.34) is discussed today largely because of Ruskin's oft-quoted declamation and the caricature it inspired by Frederick Sandys: 'The change in manner,' Ruskin stated, 'from the years of "Ophelia" and "Mariana" to 1857, is not merely Fall – it is Catastrophe; not merely a loss of power, but a reversal of principle.' These damning words, the sentiments of which were repeated in 1859 in response to *The Vale of Rest* and *Spring* or *Apple Blossoms* (fig.20), have been used by subsequent commentators as evidence that Millais's Pre-Raphaelite days were over, and he had thus begun the descent into slap-dash mediocrity. Ruskin's comments must be viewed in context. Much as he had praised *Autumn Leaves* and *Peace Concluded*, he had noted areas of 'slovenliness and imperfection'.[10] It was this freer handling of paint that Ruskin viewed as 'a reversal of principle' from the high finish of Millais's 'Pre-Raphaelite' work. In fact, Ruskin's criticisms of Millais in 1857 resemble his objections to Whistler's paintings twenty years later. In *Fors Clavigera*, published in 1877, Ruskin accused Whistler of 'flinging a pot of paint in the public's face'. This led to the Whistler/Ruskin libel trial of 1878. Thus to Ruskin, many of Millais's subsequent works were merely sketches. In 1885, he even commented on Millais's 'scornful flinging of unfinished works'.[11]

Despite this, Ruskin admired Millais. The strength of his criticisms only serves to underline how gifted he thought Millais was, but also how great he might have been (in Ruskin's opinion) had he adhered to Pre-Raphaelite principles. Thus amongst the censure there is also praise, as demonstrated by Ruskin's responses to two later paintings, *Caller Herrin* 1881 and *Ruling Passion* 1885. On the former, he remarked that 'as a piece of art, I should, myself, put highest of all yet produced by the pre-Raphaelite school' and on the latter, 'I have never seen any work of modern art with more delight and admiration than this'.[12] In the late 1850s, however, Ruskin's opinions carried extraordinary weight and were paralleled, if not imitated, by other critics and heeded by dealers and patrons. According to his son, John Guille Millais, Millais viewed these collective attacks as part of a wider conspiracy against him. Arguably they were responsible for changing the course of his career.

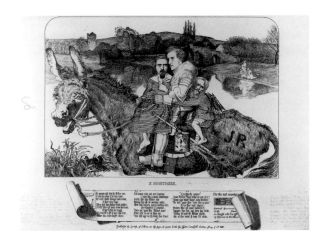

15  Frederick Sandys
*A Nightmare* 1857
Engraving
57.1 × 76.4
(22½ × 30⅛)
National Museums
of Liverpool, Lady
Lever Art Gallery

29

# 2
# BEAUTY WITHOUT SUBJECT

## Autumn Leaves

In 1853, the general assumption outside the PRB circle was that Millais led the Brotherhood. It was largely his paintings, after all, that had been the focus of the controversy. This may also have resulted from Millais's position as the prize-winning protégé of the Royal Academy and Ruskin's promotion of him through the pamphlet *Pre-Raphaelitism* (1851), which had caused a stir in artistic circles and beyond. In his *Academy Notes* of 1856, Ruskin claimed that Pre-Raphaelitism had become thoroughly assimilated into British art. Certainly the Pre-Raphaelite circle had widened. The RA exhibition of that year, for example, included Henry Wallis's *The Death of Chatterton* 1856 and Arthur Hughes's *April Love* 1855–6. It was also clear that two strands were developing through the influence of Ruskin and Millais respectively, the former focusing on landscape with artists such as John Brett and John William Inchbold, and the latter with paintings by Wallis, Hughes and William Lindsay Windus. It was in 1856, however, that Millais made a significant change of direction, characterised by the suppression of narrative and overt symbolism in favour of poetic mood and suggestion. This change perhaps resulted from a desire to strike out independently and arguably constitutes a truer reflection of his intellectual and artistic inclinations. Millais's marriage to Effie in 1855 also meant separation from his former colleagues. The new circle forming around Dante Gabriel Rossetti included Ruskin, who now sought to influence Rossetti and afterwards Edward Burne-Jones. Also in 1855, Frederic Leighton made his debut at the Royal Academy with his monumental painting, *Cimabue*, a Pre-Raphaelite subject but in a classical style. Leighton was viewed immediately as Millais's rival and thus a rallying point for his opponents.

For Millais, the late 1850s proved to be highly experimental and critically contested. In 1856, he exhibited *Peace Concluded, 1856*, *L'Enfant du Régiment* (inspired by Donizetti's opera of the same title), *Autumn Leaves* and his second completed painting on a contemporary subject, *The Blind Girl* (fig.16). It was the latter two paintings that heralded a departure. From 1852, the PRBs had begun to include modern-life subjects among their existing works. Between 1853 and 1854, Millais produced a series of drawings which found antecedents in a type of graphic illustration printed in popular periodicals and newspapers such as *Punch* and the *Illustrated London News*. The image of a fireman rescuing children from a blaze, as represented in *The Rescue* 1855, had the newsworthiness much in demand in the illustrated press. Millais utilised the popular sensationalism and modernity of the subject but elevated it to the level of High Art. A similar strategy can be seen in *The Blind Girl*. In 1853,

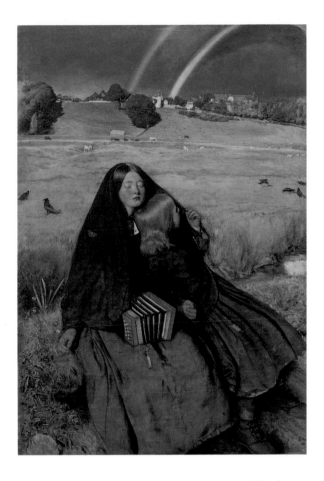

16 *The Blind Girl*
1854–6
Oil on canvas
82.6 × 62.2
(32½ × 24½)
Birmingham
Museums and Art
Gallery

Millais had produced a drawing showing a young woman leading a blind man across a crowded London street, the two perilously close to being crushed by a horse-drawn carriage, as a barefooted boy holds out his hand towards them, begging for money. This almost Hogarthian image is a commentary on the alienation and inhumanity of the over-crowded urban experience. In *The Blind Girl*, however, the social commentary on deprivation and vagrancy is more subtle and poetic.

On one level, *The Blind Girl*, in common with the contemporaneous *Autumn Leaves*, is about the senses. The blind girl rests on the bank of a stream. She touches blades of grass and raises her head to smell the breeze and feel the warm sun on her face. She listens to the sounds around her, such as the flowing stream, and music is represented by the concertina on her lap. However, the double rainbow against the stormy sky, which her companion has turned to view, is a spectacle that she cannot experience. The rainbow, of course, is the symbol of God's covenant with all living things, after the Great Flood described in the Old Testament. The Flood was His method of cleansing a corrupt and immoral world. The rainbow symbolised His promise that it would never be repeated. Here, its presence may be read as ironic, given the implied general indifference of society towards the blind girl's and her companion's

desperate circumstances. The ravens in the mid-ground, as harbingers of death, presage their fate. The painting is thus a fusion of contemporary social comment and a meditation on man's perception of the beauty and wonder of Nature.

17 *Autumn Leaves*
1855–6
Oil on canvas
104.3 × 74 (41 × 29)
Manchester Art
Gallery

Whereas the title of the painting *The Blind Girl* steered the viewer towards appreciating the painting as a genre subject, the title *Autumn Leaves* was intentionally vague. In her journal, Effie noted that Millais had 'wished to paint a picture full of beauty and without subject'.[1] What she meant by 'subject' was narrative. The setting is the garden of Annat Lodge, Perth, where Millais and Effie lived after their marriage; the time of day, an autumnal evening. In a letter to the former Brother and art critic F.G. Stephens, Millais observed that the environmental conditions he had chosen was 'really more difficult to paint than any other, as they are not to be achieved by faithful attention to Nature, such effects are so transient and occur so rarely that the rendering becomes a matter of *feeling* and *recollection*' [my italics].[2] This was a significant departure in approach from, for example, *Ophelia*. Millais's ambitions were high. He expected *Autumn Leaves*, a modern allegory on the universal theme of transience, 'to awake by its solemnity the deepest religious reflection'.[3] The solemnity that Millais spoke of is shown in the contemplative expression of the girls and their ritualised actions, as if they were engaged in a religious observance. This emphasis was lost on most contemporary commentators, who approached *Autumn Leaves* as a genre scene, albeit sombre. Ruskin, however, described it as 'the most poetical work the painter has yet conceived'. And F.G. Stephens, perhaps with a Brother's insight into Millais's way of thinking, wrote of the painting's broader symbolic and religious significance, exclaiming, 'Nothing more awful than this picture can be conceived, or out of fewer materials have we ever seen so much expressed'.[4]

Millais had also utilised the poetic resonance of an autumnal setting in *Mariana*. Traditionally, the autumn season was the time of harvest and Christian thanksgiving, but was also associated with the passage of time. It was this latter association that preoccupied Millais in *Autumn Leaves*, underscored by the evening setting – the end of the day – and the dead leaves. While the painting is a highly personal reflection on the themes previously mentioned, the association of autumn with transience and reflection was rooted in poetry. Millais's friend, William Allingham, for example, published *Autumnal Sonnet* in 1855 on exactly this theme. And in Tennyson's *The Princess* (1847), a poem Millais knew well, we find the lines:

> Tears, idle tears, I know not what they mean,
> Tears from the depth of some divine despair
> Rise in the heart, and gather to the eyes,
> In looking on the happy Autumn-fields,
> And thinking of the days that are no more.

*Autumn Leaves* is perhaps most innovative, however, in the representation of the girls, resulting from Millais's theoretical approach to ideal beauty. The models were Effie's younger sisters, Alice and Sophie, and two local girls, who feature in *The Blind Girl*. While working on *Autumn Leaves*, Millais wrote a

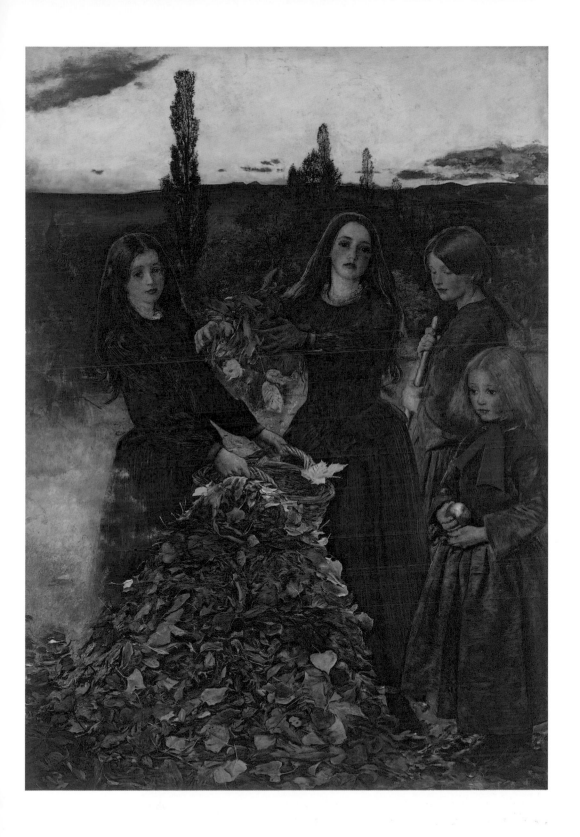

33

letter to Charles Collins, which is worth quoting extensively, as Millais written views on his theories are rare:

> The *only* head you could paint to be considered beautiful by *everybody* would be the face of a little girl about eight years old, before humanity is subject to such change. With years, features become so much more decided, expressive, through the development of character that they admit of more or less appreciation – hence the difference of opinion about beauty. A child represents beauty in the abstract, and when a peculiar expression shows itself in the face, then comes the occasion of difference between people as to whether it increases or injures the beauty ... The fact is I have been going through a kind of cross examination within myself lately as to a manner of producing beauty, when I desire it to be the chief impression.[5]

While *Autumn Leaves* was criticised for its unconventional large-scale format, Millais's pursuit of a universalised beauty within the painting appears to have succeeded. '[H]undreds,' he noted with satisfaction, 'are daily exclaiming about the extreme beauty of the heads of the children.'[6] Arguably Millais's 'cross examination' to locate 'beauty in the abstract' constitutes the starting point of Aestheticism.

## Past and Present

In *A Dream of the Past: Sir Isumbras at the Ford* 1857 (fig.18), *The Vale of Rest* 1858–9 (fig.19) and *Apple Blossoms* or *Spring* 1856–9 (fig.20), Millais continued to explore the atmospheric and emotional bias heralded by *Autumn Leaves*. *Sir Isumbras* is an imaginative variation on chivalric subject-paintings that were exhibited from the 1820s, such as Charles Eastlake's *The Champion* 1825

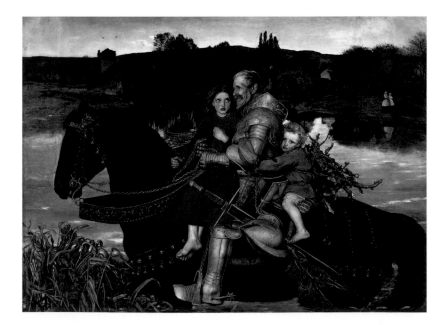

18 *A Dream of the Past: Sir Isumbras Crossing the Ford* 1857
Oil on canvas
125.5 × 171.5
(49⅜ × 67½)
National Museums of Liverpool, Lady Lever Art Gallery

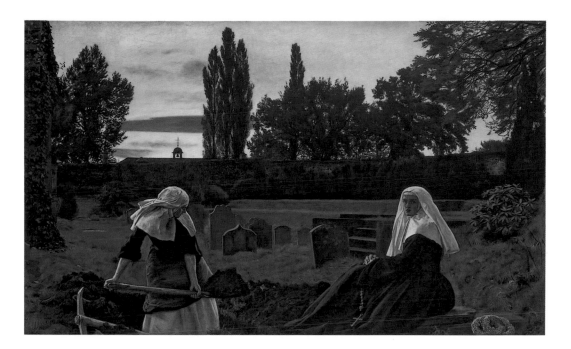

19  *Vale of Rest*
1858–9
Oil on canvas
102.9 × 172.7
(40½ × 68)
Tate

and Maclise's *Chivalric Vow of the Ladies of the Peacock* 1835. More contemporary examples were the frescos executed at the new Palace of Westminster from the 1840s by William Dyce. *Sir Isumbras* also coincided with the creation of the Arthurian murals paintings in the New Debating Hall of the Oxford Union, a project led by Rossetti, with work by Burne-Jones, William Morris and others. As with Millais's other medieval-style compositions, such as *Ferdinand and Ariel* and *Mariana*, the initial inspiration came from literature. Sir Isumbras was the subject of a fourteenth-century English romance, in which he is described as a paragon of chivalry who achieves spiritual atonement through good deeds. The scene of an aged knight carrying two peasant children across a ford was Millais's own invention. However, the painting's relationship with *Autumn Leaves* – the use of the landscape and time of day to communicate an idea rather than a specific narrative – allows us to appreciate *Sir Isumbras* as more than just a fanciful episode in Victorian Medievalism. Both paintings share the same melancholic atmosphere. Both engage with the brevity of life, in the present and in the past, and thus underline its universality and timelessness.

The play on temporality continues in *The Vale of Rest*. According to Effie, the inspiration came during their 'wedding tour' in 1855. Millais was impressed with the beauty of the scenery and the sunset at Loch Awe, near Inveraray. The couple were subsequently informed that the ruins of a monastery existed on one of the islands. The combination of scenery, sunset and the suggestion of ecclesiastical ruins clearly had a powerful effect. 'We imagined to ourselves,' Effie wrote in her journal, 'the beauty of the picturesque features of the Roman Catholic religion, and transported ourselves, in idea, back to the times before the Reformation had torn down, with bigoted zeal, all that was beautiful from antiquity, or sacred from the piety and remorse of the founders

of old ecclesiastical buildings in this country.'[7] These comments recall the influence of the Oxford Movement on Millais's early Pre-Raphaelite works, but also echo the influential writings of A.W.N. Pugin (1812–52), an architect and Catholic convert, who characterised pre-Reformation England as having religious, artistic and social integrity, the dismantling of which resulted in moral and cultural deterioration. Whereas the theme of death is oblique in *Autumn Leaves* and *Sir Isumbras*, in *The Vale of Rest* it is explicit: the digging of a grave, the skull on the seated nun's rosary and the funerary wreaths, as well as the Christian context of the nuns themselves and the churchyard setting. That the viewer is invited to contemplate his own mortality is demonstrated by the open grave extending beyond the confines of the picture and the nun looking out, acknowledging the spectator's presence. Importantly, in terms of the universality of its theme, the temporal context of the painting is ambiguous. Neither the setting nor the nuns' habits suggest any particular moment in history. Indeed the scene could be occurring in the past or the present.

In her journal entry, Effie made references to religious music, which she and Millais imagined accompanying the fanciful scene they had conjured up at Loch Awe: 'the vesper bell pealed forth the "Ave Maria" at sundown, and the organ notes of the Virgin's hymn ... carried by the water and transformed into a sweeter melody, caught up on the hillside and dying away in the blue air.'[8] Music is evoked in the composition through the bell tower, silhouetted against the sky, and in the text that accompanied the painting at the RA, 'The Vale of Rest, Where the weary find repose'. These words come from the song 'Ruhetal' (vale of rest) from Felix Mendelssohn's *Sechs Lieder*. Millais cared greatly for music and was a frequent visitor to the theatre and the opera. Whereas such visits occasionally inspired paintings, Millais had already completed *The Vale of Rest* when he heard his brother, William, singing Mendelssohn's song. To him, it conveyed (in musical terms) the mood and spiritual significance of his painting which, like *Autumn Leaves*, was conceived to provoke 'the deepest religious reflection'.

All but the musical associations of *The Vale of Rest* are explored further in the extraordinary frieze-like composition of *Apple Blossoms* (also known as *Spring*): the seasonal context denoting the cycle of life, the focus on youth and beauty in the abstract, the suppression of narrative, the sombre, ritualistic actions of the girls, and death, which is suggested by the scythe on the right, poised ominously over the body of the girl. She looks out – like the nun in *The Vale of Rest* and the central figures of *Autumn Leaves* – thereby engaging the viewer. The costumes are deliberately ambiguous, complementing the strange timelessness of the work. The orchard of apple trees in blossom may allude to the bloom of youth and beauty and its fragile, transient nature. But the allusion, as in the figure holding an apple in *Autumn Leaves*, may be the biblical fall of man and mortality or the loss of virginal innocence.

How were these complex and innovative works received by critics and visitors to the Royal Academy? The answer, on the whole, is not very well. The long and often lathered published responses underline that critics were confused and rattled by what they saw, mainly because the paintings stood outside their frame of reference. Consequently they resorted to the kind of

abusive language the PRBs had experienced in 1850–1, but framed (ironically enough) in terms of Millais's departure from Pre-Raphaelitism. Some critics even shadowed Ruskin's published criticisms. Thus the *Athenaeum* noted that 'the decline from pictures like the "Release" to "Sir Isumbras" is extraordinary'.[9] And *The Times* complained (in the spirit of 'Truth to Nature') that 'the whole foreground group [in *Sir Isumbras*] is represented under a light far more vivid and displaying local colour far more positively than is consistent with the time of the day'.[10]

For *Punch* magazine, 1859 was 'the year Mr. Millais gave forth those terrible nuns in the graveyard'.[11] Ruskin, who was clearly getting into his anti-Millais stride, summarised people's reactions to *The Vale of Rest* with the words 'frightful', 'strange' and 'horrible'. Interestingly, he described the 'wildness of execution' and 'distortion of feature' as being an effect 'sought by this painter from his earliest youth', illustrating his point with details from *Isabella* and *Christ in the House of His Parents*. And the sheer ugliness and grimness of *Apple Blossoms*, stated Ruskin, 'force upon me a strange impression, which I cannot shake off – that this is an illustration of the song of some modern Dante, who, at the first entrance of an inferno for English society, had found, carpeted with ghastly grass, a field of penance for young ladies'.[12] Thus *The Vale of Rest* and *Apple Blossoms* , both exhibited in 1859, provoked a barrage of abuse concerning their perceived ugliness. One critic even concluded that 'many are disposed to question if [Millais] is not too deficient in the appreciation of beauty to reach the highest rank of his art'.[13] This comment also represents the doubts expressed at the time concerning Millais's future. On 10 April, he wrote to Effie: 'Nobody seems to understand really good work, and even the best

20 *Apple Blossoms* (*Spring*) 1859
Oil on canvas
113 × 176.3
(44½ × 69⅜)
National Museums of Liverpool, Lady Lever Art Gallery

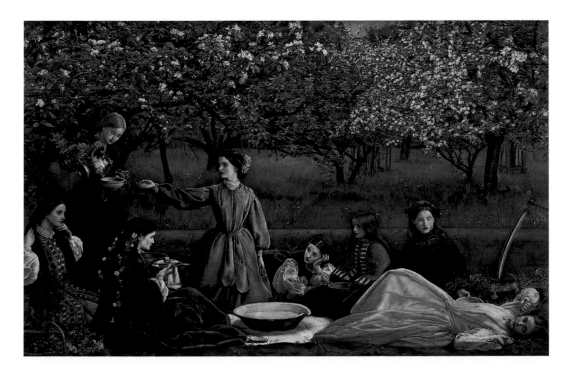

judges surprise me with their extraordinary remarks ... There seems to be a total want of confidence in the merits of the pictures, amongst even the dealers.' Indeed Millais had great difficulty selling these paintings, by his standards, which, for a married man with a growing family must have added pressure as well as fuelled his paranoia that there was a conspiracy against him from within the Royal Academy. Millais's son later recorded that 'Ruin stared him in the face – ruin to himself, his wife, and family'.[14] Perhaps not surprisingly, John Guille Millais viewed 1860 as a turning point in his father's career, when Millais painted *The Black Brunswicker* as a premeditated sequel to his first popular success, *A Huguenot*.

If the critics were unimpressed with Millais in the late 1850s, the same cannot be said for artists. Indeed his paintings proved to be highly influential, resulting in direct responses or echoes within numerous works of art. Frederick Sandys's *Autumn c.*1860–2 (fig.21) is a modern-day pendant to *Sir Isumbras*, showing an elderly soldier resting on a river bank with two children – thus a Millaisian play on past and present – conflating the mood and subject of *Autumn Leaves*, *Sir Isumbras* and *The Vale of Rest*. Arthur Hughes's *The Knight of the Sun* 1860 includes an evening setting reminiscent of *Autumn Leaves* and *Sir Isumbras*, and a chivalric subject of an ageing knight, his death approaching. And James Tissot's *Le Printemps* 1862 and Burne-Jones's *Green Summer* 1865, 1868 are, among other artistic influences, indebted to Millais's *Apple Blossoms*. Importantly, some of these artists are associated with the progressive movement in art and design called Aestheticism.

21  Frederick Sandys
*Autumn* 1860
Oil on canvas
79.6 × 108.7
(31⅛ × 42¾)
Norwich Castle
Museum and Art
Gallery

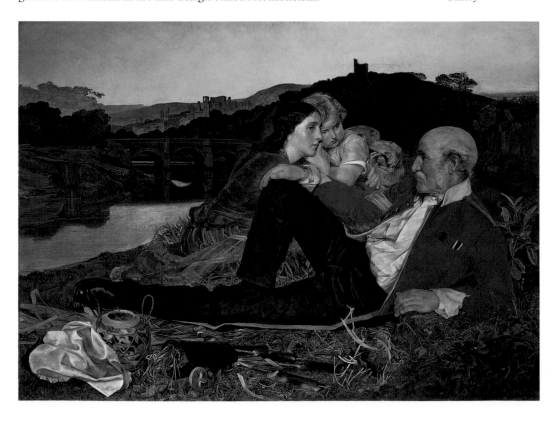

22 *Leisure Hours*
1864
Oil on canvas
88.9 × 118.1
(35 × 46½)
Founders Society
Purchase, Robert H.
Tannahill
Foundation Fund

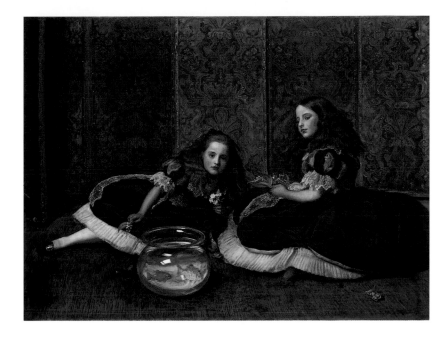

## Aestheticism and Revivalism

If Millais's mood paintings of 1856–9 played an important part in the Aesthetic Movement, *The Bridesmaid* of 1851 can be viewed as an earlier experiment, predating Rossetti's sensuous female subjects. The narrative of *The Bridesmaid* is obscured by the bold juxtaposition of colour, in particular the mass of loosened, luxuriant hair against the blue background. Millais employed a similar strategy the following decade, in *Esther* 1865. There is also a sexual focus to *The Bridesmaid*, albeit not as explicit as Rossetti's *Bocca Baciata* 1859. The intensity of the work, the spatial proximity of the woman, the upturned face and absorbed expression, all suggest that sensual appreciation was more important to Millais in constructing the image, than narrative.

Whatever the position of *The Bridesmaid* in the history of Aestheticism or indeed the second phase of Pre-Raphaelitism led by Rossetti, there is no doubt that Millais was fascinated by beauty in the abstract. Whereas for Rossetti, Burne-Jones and Albert Moore, this was explored through the representation of women, for Millais the focus was children and, to a lesser extent, adolescents. His portrait of Marion and Anne Pender entitled *Leisure Hours* (fig.22) was exhibited at the Royal Academy in 1864, a work contemporaneous with the similarly themed *Golden Hours* by Leighton and *Caprice in Purple and Gold No.2, The Golden Screen* by Whistler. As the title *Leisure Hours* suggests, the work should be viewed less as a representation of individuals with defined characters and more as an arrangement of beautiful objects. The composition of green textile flooring, red velvet and lace-trimmed costumes and the gilded screen, with the white, yellow, red, orange and blue accents of the flowers, fish and hair ribbon, is highly decorative and harmonious. A similar emphasis can be seen in Millais's portrait of Nina Lehmann (1868–9, fig.23). The girl is dressed in white muslin and is seated on a large ceramic base with a blue-

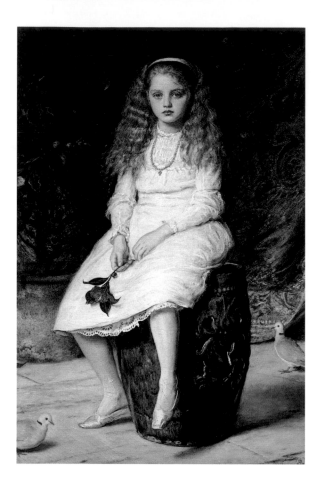

23 *Nina Lehmann*
1868–9
Oil on canvas
131.5 × 87.5
(51¾ × 34½)
Private Collection

green lustre finish, against a backdrop of figured blue fabric. The two white doves complete the arrangement of white and blue with the flowers in Nina's hand and in the planter to the left adding dramatic accents of dark pink. In both paintings, however, the children convey a mood of idleness that borders on world-weariness, contrasting with conventional representations of the time that emphasised innocence and playfulness, such as in Millais's *My First Sermon* 1863 (fig.35). This is especially true of *Leisure Hours*, as noted by W.M. Rossetti in his review published in *Fraser's Magazine*. Millais, he wrote, 'has determined that we should admire ... a picture of children, whence the charm and naïveté of childhood are absent, and in which the metallic worldly key-note struck by two girls just emerging from infancy shall be sustained throughout'. The critic thought the result was 'a strong artistic success' but observed that, 'in less strenuous hands' than Millais's, the painting would have been 'a repulsive failure'.[15] This suggests that, for a contemporary audience, Millais's portrayal of childhood was audacious, if not troubling. Importantly, Millais's *Leisure Hours* represents an early example of the burgeoning interest in Spanish art and dress from the mid-nineteenth century. The Pender sisters are wearing fancy dress in the style of Velázquez and are seated in front of a Spanish leather screen. It is possible, therefore, that Millais's portrait

not only relates to his earlier investigations into idealised beauty, but is linked to the decorous expressions and demeanour associated with seventeenth-century court portraiture.

Millais and Whistler had shared interests and inspirations at this time, a fact that has only recently been acknowledged and explored by art historians. Indeed, between these two artists, there was mutual admiration and contradiction. Whistler's first portrait to which the musical title of 'Symphony' was prefixed, *Symphony in White, No.1: The White Girl* 1862, was influenced by Millais's *Autumn Leaves*. Whistler would have seen this painting at the Manchester Art Treasures exhibition in 1857. His interest in Millais's work continued in 1859, when he and Henri Fantin-Latour visited the Royal Academy exhibition. *The Vale of Rest* (with its musical associations) and *Spring* were admired by both men for their realism and loaded atmosphere. Indeed Fantin-Latour wrote afterwards, 'Les souvenirs les plus vifs que j'ai conservés de ce temps à Londres étaient notre admiration pour l'exposition des tableaux de Millais à l'Academy.'[16] Millais, in turn, admired Whistler's *At the Piano* (exh. RA 1860) for its rich colour, and *The White Girl*. In fact his enthusiasm ran counter to the French Salon and the Royal Academy, given that both institutions rejected *The White Girl* for exhibition. Joanna Hifferman, the sitter, wrote to the American art dealer, George Lucas, in April 1862: '[the painting] has made a fresh sensation – for and against. Some stupid painters don't understand it at all while Millais for instance thinks its splendid, more like Titian and those of old Seville than anything he has seen.'[17]

Below left
24  James McNeill Whistler
*Symphony in White, No.2: The Little White Girl* 1864
Oil on canvas
76.5 × 51.1
(30⅛ × 20⅛)
Tate

Below right
25  *Esther* 1863
Oil on canvas
105.4 × 74.9
(41½ × 29½)
Private Collection

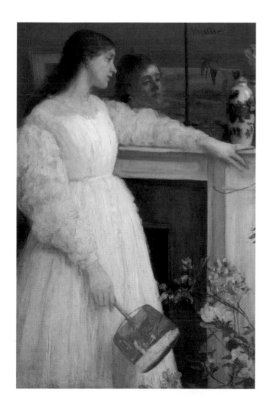

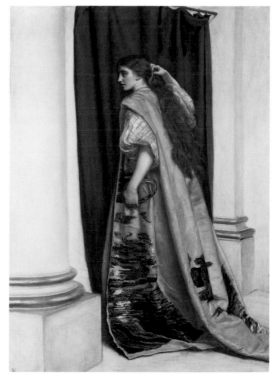

41

Critics registered this ongoing artistic dialogue between Millais and Whistler by comparing and contrasting the two artists' work. In 1869, the French critic Philippe Burty noted that Millais's *Nina Lehmann* was 'sonorous and forthright' in comparison to *The White Girl*, which was 'unhealthy and troubling'.[18] It is likely that *Nina Lehmann* was conceived as a riposte to Whistler's earlier portrait. In 1865 Whistler's *Symphony in White No.2: The Little White Girl* 1864 (fig.24) and Millais's *Esther* 1865 (fig.25) were on exhibition at the Royal Academy. W.M. Rossetti wrote in June 1865: 'The exquisiteness of the *Little White Girl* is crucially tested by its proximity to the flashing white in Mr Millais' *Esther*: it stands the test, retorting delicious harmony for daring force, and would shame any other contrast.'[19] That *Esther* is an Aesthetic Movement painting, rather than a straightforward biblical subject-painting, is clear from the emphasis placed on beauty and the decorative, rather than narrative. Queen Esther, a Jew who marries the King of Persia, risks her life by appearing before her husband without being summoned, in order to save the lives of her people. Laudable as this action was – not to say appealing to Victorian audiences – Millais was more interested in Esther's reputation as a beautiful and graceful woman. After all, the moment depicted is vague, given the sequence of events related in the Book of Esther. Instead, the viewer is more immediately struck by the dramatic juxtaposition of white, blue and yellow. According to J.G. Millais, Esther's robe was borrowed from General 'Chinese' Gordon, who had sat for Valentine Prinsep wearing the garment. Millais was fascinated by the richness of the oriental brocade, not its symbolic value (the yellow jacket was a military honour). He accentuated its purely decorative purpose by having the robe turned inside out, 'so as to have broader masses of colour'.[20]

W.M. Rossetti's characterisation of Millais's work as having 'daring force' was noted by other critics and, in the context of Aestheticism, was clearly meant by the artist as an alternative effect to that produced by Whistler and others. The portrait painter, Archibald Stuart-Wortley, described Millais guiding him around the Grosvenor Gallery one day: 'He stopped longer than usual before a shadowy, graceful portrait of a lady, by one of the most famous painters of our day – an arrangement in pink and grey ... At last [Millais said], "It's d—d clever; it's a d—d sight too clever!"'.[21] If he disapproved of Whistler's cleverness, by which he probably meant speciousness, Millais was increasingly concerned about the artist's influence, on the basis that Whistler's technique was unsound. According to the painter Briton Rivière, Millais remarked: 'I regard him [Whistler] as a great power for mischief amongst young men – a man who has never learnt the grammar of his Art, whose drawing is as faulty as it can be.'[22]

The Aesthetic Movement was perhaps the most important factor in popularising a wide range of historical dress. Millais did not respond to the synthesis of Aestheticism and Neoclassicism as represented in the work of Whistler, Leighton and Albert Moore. He did, however, play a role from the 1860s in the revival of interest in eighteenth-century fine and decorative art, which was itself an important constituent of the Aesthetic Movement. Millais's *Spring*, for example, can be read as a modern-day *fête champêtre* after Watteau and

other French Rococo artists. In 1868, Millais exhibited *Stella*, *Sisters* (a portrait of his three daughters) and *A Souvenir of Velázquez* (his Diploma painting) at the Royal Academy, all of which demonstrate – to a greater or lesser extent – Millais's idiosyncratic approach to Aestheticism. *Stella* (fig.26) is a fancy picture, showing one of the female correspondents of the early eighteenth-century writer Jonathan Swift. Millais shows her standing by a period writing desk, holding a letter and looking pensively into the distance. However, unlike the historical works of Edward Middleton Ward, Augustus Egg or William Powell Frith, which tended to present the past as a lively costume drama (often involving a cautionary tale), or indeed Millais's own popular historicist paintings, such as the *Order of Release, 1746*, the narrative is downplayed and the viewer contemplates a single female figure, in a half-length portrait format, wearing an authentic dress of Spitalfields silk from the 1730s or 1740s. These paintings not only herald the increasingly freer and impasted brushwork of Millais's mid-career, but also his adult-portrait practice that began in 1870. Significantly, *Stella* and *Sisters* were painted during a series of large-scale exhibitions of British seventeenth- and eighteenth-century and Romantic portraiture held at the South Kensington Museum in 1866, 1867 and 1868. That Millais's paintings were adroit advertisements for the artist's ability to appropriate the work of Old Masters in a contemporary artistic and social context is underlined by the spectacular portrait of Clarissa Bischoffsheim (RA 1873, fig.27), which is at once reminiscent of the past and thoroughly modern.

Below left
26  *Stella* 1868
Oil on canvas
112.7 × 92.1
(44⅜ × 36¼)
Manchester Art
Gallery

Below right
27  *Mrs Bischoffsheim*
1873
Oil on canvas
136.4 × 91.8
(53 × 36⅛)
Tate

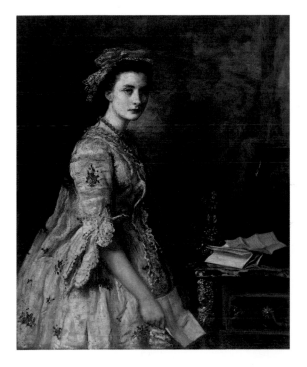

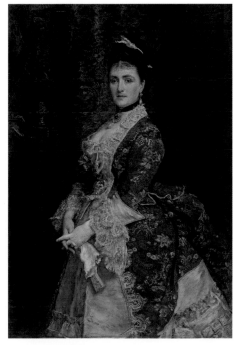

# 3

# OUR POPULAR PAINTER

## Millais as Dramatist

Emilie Isabel Barrington published an article in 1882 entitled 'Why is Mr. Millais our Popular Painter?'.[1] While her deliberations were by no means objective, thorough or complimentary to the artist, the question was a poignant one. What characterised Millais's 'popular' paintings? In May 1859, Millais wrote to his wife Effie: 'Whatever I do, no matter how successful, it will always be the same story, "Why don't you give us the Huguenot again?"'.[2] The painting, shown at the Royal Academy in 1852, was Millais's first critical *and* popular success. The *Art Journal* described *A Huguenot* (fig.28) as 'progressive', displaying 'a power and an originality which must lead to [the highest] distinction' of the British school. In contrast, the same critic thought that, in *Ophelia*, the 'artist has allowed himself no license, but has adhered most

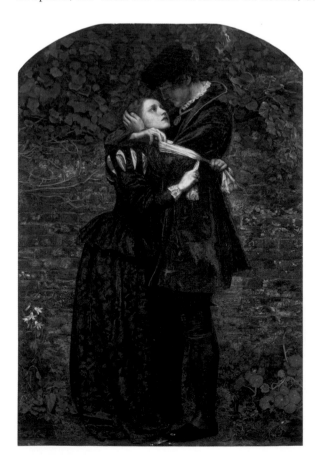

28  *A Huguenot*
1851–2
Oil on canvas
92.7 × 62.2
(36½ × 24½)
The Makins
Collection

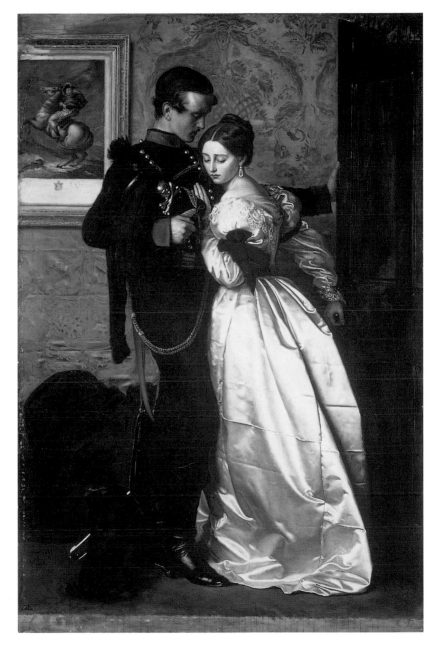

29 *The Black Brunswicker* 1859–60
Oil on canvas
99 × 66 (39 × 26)
National Museums of Liverpool, Lady Lever Art Gallery

strictly to the letter of [Shakespeare's] text ... the picture fulfils the conditions of the prescription' but 'there are other conditions naturally inseparable from the situation, which is unfulfilled'.[3] What did *A Huguenot* have, in this critic's opinion, that *Ophelia* did not? The answer is pathos. The full title of the painting was *A Huguenot, on St. Bartholomew's Day, refusing to shield himself from danger by wearing the Roman Catholic badge*. On St Bartholomew's Day in Paris in 1572, thousands of Huguenots (French Protestants) were killed on the orders of the Catholic Duc de Guise. Millais's provocative painting, *Christ in the House of his Parents* (exh. 1850) was attacked, in part, for its High Church

symbolism. This non-confrontational work, however, shows a Protestant refusing to be shielded by his Catholic lover. It thus constituted (unlike the ambiguous *Ophelia*) a gratifying and incontrovertible display of moral conviction and heroic sacrifice that chimed with prevailing social values.

The scene depicted in Millais's painting was topical in a broader cultural context, being inspired by Meyerbeer's opera *Les Huguenots*, performed at Covent Garden annually from 1848, and which Millais had seen. In Act V, the Protestant Raoul de Nangis refuses the white band offered by his lover, the Catholic Valentine. Through his example, she converts to Protestantism and both die in the massacre. The romantic notion of doomed love is emphasised by the overt attractiveness of Millais's figures. But what distinguishes *A Huguenot* is not the period subject, moral significance or topicality, but rather its legibility to a broad public and the subtlety with which Millais communicates the drama and consequences of the moment, largely achieved through the actions of the protagonists' hands; as she, in desperation, tightens the white band, he gently persuades her to release it, pulling with one hand, while tenderly cupping her face with the other. Such understatement and compassion characterises Millais's approach to human relationships, particularly with scenes involving lovers. This is evident from his earliest paintings, such as *Isabella*, and recurs in later works, for example in the contemporary subject entitled *Yes* 1877 (fig.31). *A Huguenot* also demonstrates Millais's approach to narrative and his selection of a defining moment. As M.H. Spielmann noted, he was 'a dramatist, with the true artist's instinct of leaving his drama unfinished, though usually suggested'.[4]

Millais's historical genre paintings find antecedence in the Romantic period as part of a redefinition of what constituted history painting. In his fourth *Discourse* of 1771, Joshua Reynolds had stated that the subject of history painting 'ought to be either some *eminent instance of heroick action or heroick suffering ...* in which men are universally concerned, and which powerfully strikes upon the publick sympathy'.[5] Eighteenth-century convention thus largely dictated that the theme was exemplary and universal. Just as the idea of the heroic was adapted by Romantic individualism, so was the depiction of history, which became more inclusive, featuring the actions and experience of ordinary people as much as those of kings, deities and national heroes. The historical novels and verse narratives of Walter Scott, in particular, presented the past not as remote and strange but as accessible, populated by human beings with the foibles, passions and sensibilities of their modern-day counterparts. Millais's *Order of Release, 1746* and *Idyll of 1745* 1885 were responses to the ongoing popularity and influence of Scott in the context of Anglo-Scottish history, just as his *Effie Deans* 1877 and *The Bride of Lammermoor* 1878 illustrated specific Scottish-based novels by Scott which – characteristically for Millais – show a private moment between a male and female character.

The Romantic notion of a common history and experience is played out in Millais's work through the recasting of a single theme in numerous historical and contemporary contexts. *The Black Brunswicker* (fig.29), exhibited to critical and popular acclaim in 1860, was devised by Millais specifically as 'a per-

30 *The Princes in the Tower* 1878
Oil on canvas
147.2 × 91.4
(58 × 36)
Royal Holloway,
University of London

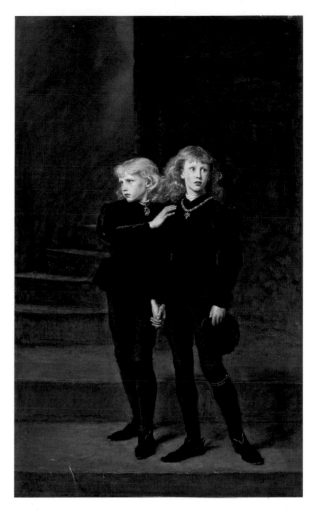

fect pendant to "A Huguenot"', and thus shares compositional and dramatic devices. The subject is a German 'Brunswicker' cavalryman, taking leave of his English lover to participate in the Battle of Waterloo (1815). Most of the regiment died during the battle. The contemporary resonance of the painting is the conclusion of the Crimean War in 1856 and the French invasion threats during the 1850s by Napoleon III (Jacques-Louis David's portrait of Napoleon Bonaparte hangs on the wall). *The Black Brunswicker* can, in fact, be seen as the fourth of similarly themed paintings, which count among Millais's most admired exhibited works, all of which were subsequently engraved. Indeed J.G. Millais wrote that *A Huguenot* 1851–2, *The Proscribed Royalist* 1852–3, *The Order of Release, 1746* and *The Black Brunswicker* were loosely devised as a historical sequence depicting 'unselfish love, in which the sweetness of woman shines conspicuous'.[6] More importantly for Millais's contemporary audience, all of these works show ordinary people caught up in the cultural divisions and conflicts of their day – which clearly appealed to Millais's sense of the dramatic – from the religious wars of the sixteenth century, to the English Civil War (1642–9), the Jacobite Rebellion (1745–6) and the Napoleonic Wars

47

Above left
31  *Yes* 1877
Oil on canvas
152.4 × 116.8
(60 × 40)
Collection of Lord
Lloyd-Webber

Above
32  *Accepted* 1853
Pen and brown ink
on paper
25.1 × 17.5
(9⅞ × 6⅞)
Yale Center for
British Art, Paul
Mellon Collection

(1799–1815). Thus their popularity results directly from the immediacy of the moment and the viewer's subsequent ability to relate to and empathise with the protagonists. Ordinary people taking heroic action or making sacrifices is carried forward into the modern day with Millais's *The Rescue* 1855, which could be seen as a pendant to *The Order of Release* or indeed a modern example of chivalric rescue, as seen in *Sir Isumbras at the Ford* and *The Knight Errant* 1870 (fig.45).

Returning to a theme also occurs in Millais's interpretation of events involving historical child figures. His *Princes in the Tower* 1878, for example, is paired with his representation of the captivity of Charles I's daughter in *Princess Elizabeth in the Tower* 1879, all of whom are innocent victims of power politics and civil war, just as *The Childhood of St Theresa* 1893 can be read as a pendant to the fictive *The Boyhood of Raleigh* 1874 (fig.38). His popular *Princes in the Tower* (fig.30) is a riposte to Paul Delaroche's earlier version of the same subject, *The Children of King Edward Imprisoned in the Tower* shown at the Paris salon of 1831. Delaroche enjoyed tremendous popular success in France, Britain and elsewhere, from the late 1820s because his historical genre subjects, often based on British history, were theatrical, even melodramatic, highly legible and thus accessible. His interpretation of this emotive subject of the murder of Edward IV's children in the Tower of London was probably his best-

known work in Britain during Millais's lifetime. Indeed a reduced oil version of the Frenchman's painting was on exhibition from the collection of Sir Richard Wallace at the Bethnal Green Museum, London, from 1872 to 1875. It shows the princes seated on a bed, distracted from the prayer book they were reading, the dog to their left alerted to the shadow at the door behind them, suggesting the presence of the murderers. This contrasted with other interpretations in British art. James Northcote's *Scene from Richard III* 1790, for example, shows the children asleep with their murderers poised, ready to smother them. Millais pares down the narrative even further by showing the princes, blond and beautiful, standing on a prison stairwell, anxiously looking into the shadows. As with *A Huguenot*, the sense of danger and approaching tragedy is gently communicated through expression and gesture, of which Millais was a master. In this particular instance, by utilising his audience's familiarity with history or specifically Delaroche's work, he downplayed storytelling and focused on the pathos of doomed youth.

In parallel with the democratising of history was the moralising agenda of historical genre in the Victorian period. It has been observed that nineteenth-century readers looked to the past 'not merely for its intrinsic interest but for a fuller understanding of the religious, moral, and political issues of their own time'.[7] In this context biographies and historic writings were as important for providing role models and cautionary tales as for the information they contained. This is particularly true of paintings by Millais's contemporaries E.M. Ward and Augustus Egg, which were also indebted to William Hogarth's well-known modern moral subjects. Interestingly, Millais did not execute such overt social commentaries or comparisons between history and the contemporary world in his paintings, preferring instead to provoke an empathetic response towards his protagonists. As previously noted, however, Millais had executed a series of drawings between 1853 and 1854 on contemporary-life subjects in a Hogarthian vein, including male/female relationships and marriage, such as *Accepted* (fig. 32, a marriage proposal scene, which Millais

returned to in a more understated form in *Yes*) and *Retribution* (the discovery that a young woman's lover is already married). These drawings have an aura of the contemporary novel or even melodrama – just as Millais's historical works often smack of the interconnected world of historical novels, theatre or opera – and act as precursors to his successful and lucrative career as an illustrator. The *Cornhill Magazine*, launched in 1860 with William Thackeray as its first editor, published Millais's illustrations to Anthony Trollope's *Orley Farm* (serialised in monthly parts between March 1861 and October 1862). His *Lady Mason after her Confession* 1861 (fig. 34) must rank as one of the finest of these illustrations, subtly communicating, through the hunched figure cloaked in darkness, both the harrowing effects of long-concealed guilt and foreshadowing the punishment she cannot escape.

## 'Charming, loveable, covetable work'

Art dealers were crucial figures in the increasingly buoyant Victorian art world, not only because they were establishing themselves as the 'middle men' between the artist and the wealthy middle-class buyers, but because they purchased copyright and published prints after contemporary British art. Ernest Gambart and William Agnew were the most important dealers during Millais's career. Both exploited the fine-art print market. Prints had the advantage of being comparatively cheaper and more numerous than a painting and, depending on the quality of the reproduction, were perceived as prestigious objects that could be hung in the same way as paintings. The difference between the nineteenth century and previous centuries was the development of new reproductive techniques, raising the number of potential images into six figures as well as the explosion in the number of newspapers, magazines, periodicals and other printed matter in which images could be reproduced. Publishers often paid large sums to artists to purchase the copyright for paintings that were perceived as 'commercial'. That Millais's *A Huguenot* was bought by the dealer D.T. White was an indication from the art trade of what constituted 'popular appeal' in art. White financed the production of a mezzotint by Thomas Oldham Barlow, which was published along with a print of *The Order of Release* in 1856. Henry Graves published prints of *A Huguenot* and *The Order of Release* and, in 1864, one of *The Black Brunswicker*. What this exposure could do for the artist, through the proliferation of images, is indicated by the comments made by William Thackeray, later described by Millais's brother William:

> I was sitting with my brother in the Cromwell Place studio when
> Thackeray suddenly came in all aglow with enthusiasm at my
> brother's fame. Every window in every shop that had the least
> pretension to Art-display, he said, was full of the engravings of his
> popular works. On his way he had seen innumerable 'Orders of
> Release,' 'Black Brunswickers' and 'Huguenots'; in fact, he had no
> hesitation in affirming that John Millais was the most famous man
> of the day.[8]

35 *My First Sermon*
1863
Oil on canvas
92 × 76.8
(36¼ × 30¼)
Guildhall Art
Gallery, Corporation
of London

36 *My Second
Sermon* 1864
Oil on canvas
97.1 × 71.7
(38¼ × 28¼)
Guildhall Art
Gallery, Corporation
of London

That Millais produced paintings that were 'commercial' is not in dispute, an example being *My First Sermon* (fig.35). In *The Reaction from Pre-Raphaelitism* (1864), Philip Gilbert Hamerton described Millais's painting as 'a most charming, lovable, covetable work ... It is a quite successful bit of popular painting'.[9] Hamerton's comments indicate that Millais's growing popularity in the 1860s was fuelled specifically by his studies of children. Their status as 'covetable work' was arguably promoted, rather than undermined, by the opportunities afforded by printed reproductions. *My First Sermon*, featuring the artist's daughter Effie, received widespread praise at the Royal Academy exhibition of 1863, the same year that Millais was elected a Royal Academician. Millais followed this painting by *My Second Sermon* (fig.36), showing the child in the same clothes and location, but asleep. This joke on the child's short-lived enthusiasm for church sermons was calculated to reinforce the charm factor but also, like the latter-day Hollywood sequel, to capitalise on a winning formula, and both works were reproduced as a pair of engravings in 1865 by Henry Graves. The success of these two paintings can be seen as a benchmark in Millais's reputation as the nineteenth-century painter of children, both in subject-paintings and portraits. *My First Sermon* was adapted for Millais's portrait of Lilly Noble (1863–4) and in 1864, the artist and his artistry became 'the subject' in John Ballantyne's *Millais Painting 'My Second Sermon'*, which was reproduced as a chromolithograph by V. Brooks.

From the 1860s, Millais's portraits and child subject-paintings increasingly responded to Old Master portraiture and the type of 'fancy picture' identified with Joshua Reynolds and other eighteenth-century painters, of which *Cherry Ripe* 1879 and *Bubbles* 1885 (fig.37) are the best-known examples. It is interesting to note, therefore, that Reynolds actively encouraged the publication of prints after his works (a practice already established by portrait painters) as free publicity, and produced speculative paintings of celebrities and children for the print market. Millais's *Cherry Ripe* quotes *Penelope Boothby* by Reynolds, and thus is in the spirit of Reynolds' portrait of Master Crewe, who is dressed and posed as Henry VIII, after Hans Holbein's celebrated portrait. *Master Crewe* was published as an engraving in 1776 by the entrepreneurial Alderman Boydell. *Cherry Ripe* is a portrait of Miss Edie Ramage who had attended a fancy-dress ball organised by the *Graphic* magazine as *Penelope Boothby*. The editor of the *Graphic* was Edie's uncle, William Thomas. Thus *Cherry Ripe* is a more complex reflection of fashion, revivalism and promotion through popular publications in late Victorian society, than simply an artistic pastiche.

By the 1880s, printed reproductions included chromolithographs and photogravures. In 1880, *Cherry Ripe* was printed in colour and inserted into the Christmas number of the *Graphic*. An astonishing 600,000 magazines were reportedly sold. On the other end of the scale, many of Millais's paintings were published as wood engravings in the *Illustrated London News*, a testament to his standing as an artist. These included works without 'popular appeal' and, in the case of *Christ in the House of His Parents*, notoriety. J.G. Millais registered how far prints of his father's works had travelled across the world, having seen *Cherry Ripe* in a 'Tartar's hut', *Cinderella* 'gorgeously framed in the house of

37 *Bubbles* 1886
Oil on canvas
109.2 × 78.7
(43 × 31)
Elida Gibbs
Collection, London

a Samoan chief' and *The North-West Passage* 1874 in 'the remote wilds of South Africa'.[10] That they were also popular in America is underlined by Aaron Draper Shattuck's *The Shattuck Family* 1865, which shows the family seated in an interior with a framed print of *A Huguenot* on the wall.

Only *Bubbles* among Millais's works had the 'distinction' of being used for an advertisement. Thomas Barrett of A. & F. Pears and later William Lever of Lever Brothers and other middle-class businessmen realised the potential of using fine art to sell commercial products. The notion of heavily advertised brand names was learnt from American promotional practices, which anticipated twentieth-century advertising and marketing strategies. Barrett, however, was a pioneer in the use of fine art. In the 1870s he commissioned a scene of two monks shaving and washing, entitled *Cleanliness is Next to Godliness*, from Herbert Stacy Marks. It is not surprising that he should have alighted on *Bubbles* as a suitable image to sell soap. Originally entitled *A Child's World*, the painting was produced apparently for Millais's own pleasure (with perhaps one eye on the print market) and included in his retrospective exhibition at the Grosvenor Gallery in 1886. It was then purchased with copyright by Sir William Ingram for the *Illustrated London News*'s 1887 Christmas issue and afterwards sold to A. & F. Pears. Although the company held copyright of the painting, permission was required from Millais to include a bar of soap and text on the poster image. According to J.G. Millais, he agreed with great reluctance, swayed by the high quality of the reproduction in comparison to the numerous low-grade images after his paintings. Millais's assumed complicity in the repackaging of a work of art as a marketing tool was much commented upon. In the bestselling novel, *The Sorrows of Satan* by Marie Corelli (1895), the high-brow writer Geoffrey Tempest states:

> I am one of those who think the fame of Millais as an artist was marred when he degraded himself to the level of painting the little green boy blowing bubbles of Pear's soap. *That was an advertisement*, and that very incident in his career, trifling as it seems, will prevent his ever standing on the dignified height of distinction with such masters in Art as Romney, Sir Peter Lely, Gainsborough, and Reynolds.[11]

In his biography of 1899, J.G. Millais was compelled to include a four-page explanation setting out the genesis and appropriation of the work as an advertisement icon and refuting accusations by Corelli and others that Millais had contributed to the commodification of culture and the degradation of art. For businessmen and art collectors like Barrett and Lever, the use of art in this context was a straightforward case of enlightened self-interest, on the basis, as Lever stated, that 'the best works by the best men' were finding their way as advertisements and packaging, into the homes of the working classes.[12] Such 'popularist efforts' were encouraged by some members of the art press, notably the editor of the *Magazine of Art*, M.H. Spielmann. Others bemoaned the democratising of art and the attendant compromising of artistic integrity, calling instead for the reinstatement of aristocratic standards and attendant systems of patronage. For these art commentators, Millais was emblematic of such developments, hence the furore surrounding *Bubbles*. Joseph and Eliza-

beth Pennell, supporters of Whistler and the Aesthetic Movement, published an article in the *Fortnightly Review* at the time of Millais's death. 'By the general public,' they noted, 'he was never really appreciated until he stooped to its level ... to concede to the popular taste is to betray the dignity of art, and it is kinder to forget that the man who, in youth, painted the "Ophelia", in maturity was guilty of the mere pretty, flashy Christmas supplement.'[13]

## Ruling Passions

In his biography, Alfred Lys Baldry quoted Millais as saying that 'no artist ever painted more than four or five masterpieces ... for such success depends upon the coincidence, not only of genius and inspiration, but of health and mood and a hundred other mysterious contingencies'.[14] Using Millais's dictum, Baldry selected five subject-paintings that qualified as what he called 'monumental works'. This was based on 'their wonderful vitality, their deep significance, and force of expression'. He concluded that: 'Their qualities are those that come from a minute insight, not only into details of character, but also into the principles which govern the dramatic side of pictorial art.'[15] The works cited were *The Order of Release*, *The Vale of Rest*, *The Boyhood of Raleigh*,

38  *The Boyhood of Raleigh* 1870
Oil on canvas
120.6 × 142.2
(47 × 56)
Tate

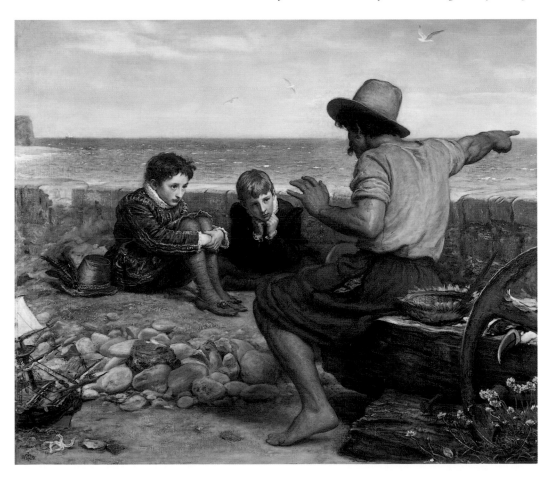

*The North-West Passage* and *Ruling Passion* (figs.14, 19, 38, 39 and 40). In the current art-critical climate the first two works would not raise eyebrows. What of the others? Both *The Boyhood of Raleigh* and the *North-West Passage* were extremely popular in the Victorian period. That fact alone would cast doubts over their current value as works of art. They were also appreciated as patriotic, arguably another barrier. And *Ruling Passion*? A straightforward piece of bourgeois sentimentalism replete with pretty children, a patriarchal figure and a paragon of motherhood? Surely these paintings fit Alan Bowness' description of Millais's work, post-Pre-Raphaelitism, as 'lovely passages of paint, but such vacuity behind the conception'.[16]

It is undeniable that, after the contested period of the 1850s, Millais produced more subject-paintings that were accessible to a wider audience. But inclusiveness does not preclude innovation, complexity or subtlety. This is true of both *The North-West Passage* and *Ruling Passion*. M.H. Spielmann described *The North-West Passage* as 'a picture of the Rule Britannia kind, but of a very high order'.[17] The painting was accompanied in the RA exhibition catalogue by the lines, 'It might be done, and England ought to do it'. The choice of subject was opportune, as plans for another expedition to the Arctic had been announced. J.G. Millais underlined the painting's patriotic (thus popular) appeal, describing it as 'an expression more eloquent than words of the manly

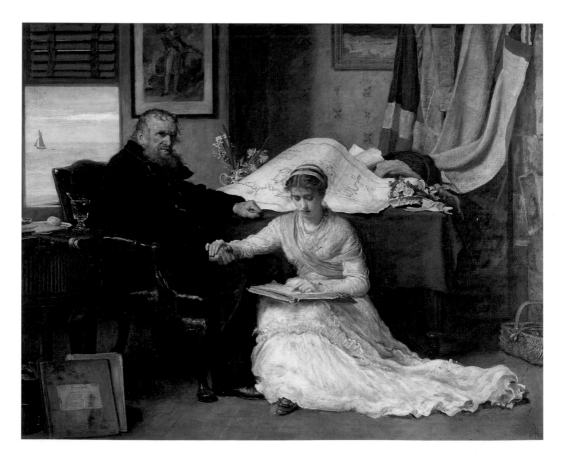

39 *The North-West Passage* 1874
Oil on canvas
176.5 × 222.2
(69½ × 87½)
Tate

enterprise of the nation and the common desire that to England should fall the honour of laying bare the hidden mystery of the North'.[18] This is demonstrated within the composition by the Royal Naval Ensign, the portrait of Horatio Nelson and the figure of the old sailor – surrounded by Arctic maps and voyage narratives/journals – representing the qualities of stoical courage and intrepidity, promoted at that time as integral to the national character. *The Boyhood of Raleigh* is in a similar vein to Millais's *Princes in the Tower*, in featuring an actual historical figure, albeit participating in a scene of the artist's own invention. Walter Raleigh was one of the most celebrated explorer-adventurers of the Elizabethan age. Millais characterises him, during a moment of youthful inspiration, as a figure of vision and destiny. The toy ship on the left and the birds on the right, make reference to the exotic locations described by the Genoese sailor, pointing to the horizon, and portend Raleigh's own journeys. These two paintings thus celebrate England as a nation of enterprising explorers, navigators and colonisers, past and present. The theme develops within *The North-West Passage* through the figure of Nelson, the most celebrated hero of the Royal Navy.

The general themes of these paintings appear to be patriotism and heroism. But they could also be interpreted as reflections on mortality (an important theme for Millais) and the vicissitudes of life. In his last years, Walter Raleigh was imprisoned on a charge of treason and subsequently executed, a victim of realpolitik. And Nelson had died during the Battle of Trafalgar of 1805, shortly after victory was won. Tragedy and sacrifice pervade the history of Arctic exploration and the search for the North-West Passage. From the sixteenth century, European nations explored the maze of islands and ice of northern Canada and the Arctic for a passage that would offer a safe sea route to Asia. During the Victorian period, the search was part of a larger project to complete geographical knowledge of remote regions, thus fulfilling the historical aims of the Elizabethans. In time, the North-West Passage became synonymous with adversity and death, with men and ships battling against hopeless odds in a frozen wilderness. Millais refers to the punishing terrain in the small painting of a ship overwhelmed by a landscape of ice. The British public was fascinated by information concerning such journeys. But the wisdom of sending expeditions to search for the North-West Passage was debated in newspapers and journals throughout the nineteenth century. In 1847, the nation had been gripped by news of the disappearance of Sir John Franklin and 134 sailors and officers. Numerous government- and privately-funded search parties were sent out to look for the missing men. This led to most of the Arctic coast being surveyed and charted and new discoveries being made. On returning from one such expedition, Dr John Rae delivered a report to the Admiralty in 1854, which gave evidence that some survivors had resorted to cannibalism. After publication, the report was met with shocked disbelief by many, including Charles Dickens, who printed two articles in *Household Words* refuting the accusations, largely on the basis that Franklin and his men were British and of 'good character'.

In selecting and interpreting this subject, Millais would have had previous artistic representations of Arctic exploration in mind. In 1863, Frederick

Church exhibited a monumental painting entitled *The Icebergs* to great acclaim in London. It had been reworked to include the mast of a wrecked ship in the foreground, forming the shape of a cross. This ambiguous addition perhaps represented the futility of human endeavour, Christian salvation or both. Poignantly the exhibition was attended by Franklin's widow and several veterans of Arctic exploration. Edwin Landseer's similarly themed *Man Proposes, God Disposes* was exhibited at the RA the following year. Landseer's powerful (if, to our eyes, melodramatic) painting shows polar bears tearing at a sail and gnawing on human bones. Given these two recent precedents and the Romantic tradition (in particular the work of Caspar David Friedrich) to which they are responding, it is important to note that Millais does not set his painting in the Arctic region but in a house on the coast of England. The painting in the back of *The North-West Passage* perhaps alludes to Church's or Landseer's emotive representations. But Millais has arguably presented himself with a more difficult challenge in conveying significance indirectly. Clearly his strategy was to utilise the public's familiarity with the subject and perhaps other artistic representations and encapsulate this, with tremendous subtlety and pathos, through the expressions and gestures of the figures. The mood of the painting is thus sombre and pensive rather than overtly jingoistic and euphoric. The calm sea-view, contrasted with the Arctic-landscape painting on the wall, underlines the remoteness of the British public, who read accounts and judge the actions of men, like Franklin, in the comfort of their homes. The old sailor's grim, distant look and clenched fist denote his reflections on the risks and hardships of such a journey. And the young woman responds by holding his hand in a gesture of comfort and understanding.

*Ruling Passion* is similarly concerned with obsession, life and death. Indeed it can be related to Millais's earlier reflections on beauty, decay and mortality, as in *Autumn Leaves*. The transience of life can be seen through the ages of the figures within the painting, from children and teenagers, to mature adults and finally the elderly. Death surrounds them all in the form of bird specimens. Those situated in the centre of the composition are birds of paradise, a reference to the enduring fascination with the exotic and perhaps the kingdom of heaven. These spectacular birds make a startling contrast with the drab and tonal quality of the rest of the composition. J.G. Millais, an ornithologist himself, records that the painting was inspired by a visit to John Gould, the leading ornithologist in Britain, who had devoted over fifty years of his life to the study of birds. By the time of his visit in 1880, Gould was an invalid and died soon afterwards.

Gould was celebrated for a series of deluxe folios consisting of beautiful hand-coloured lithographs with descriptive commentary. The splendidly coloured birds within *Ruling Passion* might be a reference to these highly prized illustrations. Ruskin, who admired this painting, had a long-standing interest in ornithology and valued Gould's work. The two men also opposed Darwinism. Gould knew Charles Darwin professionally and was employed, after Darwin's return from the *Beagle* voyages (1831–6), to identify bird species and provide illustrations for his book, *The Zoology of the Voyage of HMS Beagle*. The folios produced by Gould after this date were appreciated at the time as

visual challenges to Darwin's theory of natural selection. Whereas Darwin saw evidence of the instability of species and the importance of variation, and challenged the traditional notion that nature reflected the power of God the Creator, Gould saw evidence of the fixity of species and the hand of the Divine. Gould's folios showed the birds animated, as living creatures, rather than static, as scientific specimens, thus seeking to assert a spiritual value to bird behaviour. That Millais was sympathetic to Gould's ideas is suggested by J.G. Millais's comment, that 'To him all Nature was but "the garment of the living God"'.[19] Evidently, ornithology was a subject through which one of the most revolutionary and controversial theories of the nineteenth century, as expounded in Darwin's *The Origin of Species* (1859), was debated and contested. Far from being a straightforward piece of Victorian sentimentalism, as we may perceive it, *Ruling Passion* may well have struck a late nineteenth-century audience as a complex meditation on contemporary enquiries into Nature and Creation, and the interrelationship between science, religion and art.

40 *Ruling Passion*
(*The Ornithologist*)
1885
Oil on canvas
160.7 × 215.9
(63⅜ × 85)
Glasgow Museums:
Art Gallery and
Museum,
Kelvingrove

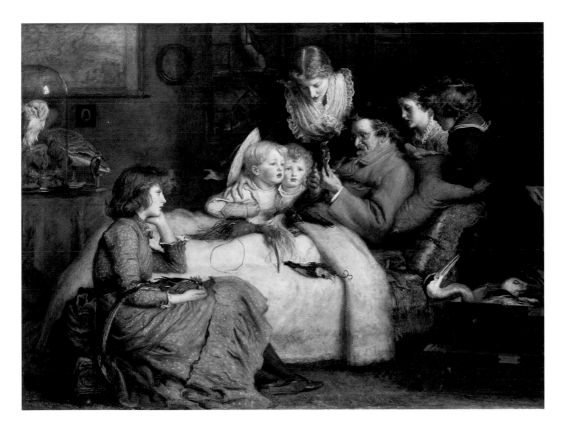

# 4

# OLD MASTERS,
# NEW DIRECTIONS

## A Souvenir of Velázquez

In 1868, Millais submitted his Diploma painting, *A Souvenir of Velázquez* (fig.41), to the Royal Academy. This marked the period in the 1860s and 1870s when his admiration for the seventeenth-century court painter was at its height. Spanish art, above all the work of Bartolomé Esteban Murillo (who influenced Gainsborough and Reynolds) and Diego Velázquez, had been of interest to aristocratic collectors from the beginning of the eighteenth century. By the 1880s, many of Velázquez's paintings were in British collections. A broader interest in him was stimulated by the publication of biographies, as well as public events such as the Manchester Art Treasures exhibition of 1857, which included twenty-six attributed works including two child portraits of Prince Baltasar Carlos, *Lady with a Fan* and the so-called *Rokeby Venus c.*1648. Millais had a more immediate prompt, a copy of Velázquez's most celebrated work at the time, *Las Meninas c.*1656, which hung in the Diploma rooms of the Royal Academy. It was owned by John 'Spanish' Philip, who had bought Whistler's *At the Piano*, itself influenced by Velázquez and admired by Millais. While Millais's diploma work does not correspond directly with any of the figures in *Las Meninas*, he clearly sought to make visual connections with the centrally placed Infanta Margarita, with her long blonde hair and composed, decorous expression directed at the viewer, as well as, more indirectly, the evident wealth, fame and prestige of Velázquez himself, who is seen painting to the Infanta's left.

Millais's technique had broadened during the mid-1850s. But why, in 1868, did he align himself so explicitly with Velázquez? The answer lies in what the Spanish artist represented for the numerous artists, from the Romantic period onwards, who responded to him. Reviewing the Manchester Art Treasures exhibition, Théophile Thoré described Velázquez as 'the most painterly painter who ever lived', an opinion repeated by Édouard Manet in a letter to Fantin-Latour in 1865.[1] Throughout his career, Velázquez had rejected idealising tendencies, seeking instead an intimacy, directness and subtle naturalism, which might almost serve as Millais's artistic credo from the 1860s onwards. Velázquez's mature style – a technique developed from the Venetian school and exemplified in *Las Meninas* – was characterised by free brushwork, with daubs of paint deliberately and economically applied to the canvas surface. His portraits often show the face painted in detail, but the rest of the surface dematerialises through the restive brushstrokes, leaving the eye of the viewer to complete the forms and patterns. Millais clearly applied his own interpreta-

41 *A Souvenir of Velázquez* 1868
Oil on canvas
102.7 × 82.4
(40⅜ × 32½)
Royal Academy of
Arts, London

tion of this formula to, for example, *A Souvenir of Velázquez*, the portraits of Louise Jopling and Kate Perugini (figs.46 and 48) and the group portrait of the Armstrong sisters, *Hearts are Trumps* 1872 (fig.43). Paul Barlow has recently argued that, despite Millais's rejection of avant-garde experimentalism and the desire to confront, as seen in the art of Manet, both artists showed comparable responses to Velázquez in paintings such as the portrait of Jopling and Manet's *Lola de Valence* 1862. Barlow sees an equivalent dialogue in terms of form, colour and composition between *Las Meninas* and *Ruling Passion*, in which, he argues, Millais sought to 'modernise Velazquez.'[2]

Millais's Old Master inspirations were not restricted to Velázquez. Indeed his youthful interest in Rembrandt also resurfaced at this time. This is not surprising, as the two seventeenth-century artists were often compared (Millais mentioned them both in his *Thoughts on Our Art of To-day*). For example, in 1910, John Collier (then Vice President of the Society of Portrait Painters and a friend of Millais) published a treatise on portraiture, describing Velázquez

and Rembrandt as 'the greatest portrait painters' and 'the greatest exponents of the technique of oil-painting'.[3] Millais's portrait of Cardinal Newman employs the plain background characteristic of Velázquez and Rembrandt and other seventeenth-century painters such as Frans Hals. Millais was here given a rare opportunity in male portraiture at this time, a spectacularly colourful costume. The suggestion to paint this high-ranking Catholic churchman came from an equally high-ranking Catholic peer, the Duke of Norfolk. Thus the portrait takes its cue from the tradition of papal portraiture, headed by Raphael (Leo X), Titian (Paul III) and Velázquez (Innocent X), and the more recent British example by Thomas Lawrence (Pius VII). F.G. Stephens, in his enthusiastic review, named a gamut of Italian painters (Titian, Tintoretto, Sebastiano del Piombo and Agnolo Bronzino) as fore-runners to this 'splendid study of deep rose red and carnation tints'. He concluded, however, that Velázquez was the primary model: 'The brilliant illumination, the handling, frank and firm, somewhat free, if not loose, and the general simplicity of the means employed by Mr Millais are Sevillian rather than Venetian.'[4]

Millais's engagement with the Old Masters was undoubtedly fuelled by the large-scale exhibitions such as that in Manchester in 1857 and the three London exhibitions in the 1860s of British seventeenth- and eighteenth-century and Romantic portraiture, including Anthony Van Dyck, William Hogarth, Gainsborough, Reynolds, Henry Raeburn, George Romney and Thomas Lawrence. These exhibitions were crucial in re-establishing reputa-tions, developing a canon of 'Old Masters' and promoting a sense of achieve-ment and patriotic pride in the British school. Clearly it was a strategic engagement on Millais's part, with the aim of presenting himself as the heir to what was an increasingly revered tradition. The National Portrait Gallery had been formed in 1856, during a period when professional portrait painting was in a period of decline. Thus *A Souvenir of Velázquez*, which is a conflation of a seventeenth-century Infanta and a Reynolds fancy picture, can be read as a declaration of both Millais's stylistic affiliations and broader artistic ambi-tions. A similar merger occurs in *Hearts are Trumps*. In his biography, J.G. Millais described how his father had been provoked into painting a triple por-trait after reading a review stating that he was 'quite incapable of making such a picture of three beautiful women together in the dress of the period as Joshua Reynolds had produced in his famous portrait of "The Ladies Walde-grave"'.[5] Whether this story is true or not, Millais knew the Reynolds portrait and, as with his child portraits and fancy pictures, may have taken this as another opportunity to measure himself against the first President of the Royal Academy. The compositions are loosely in mirror images, with each sit-ter similarly looking in different directions, two sisters silhouetted against a red silk swag or black lacquer screen, the third against a view to a landscape or flowers in a conservatory. The parallels between the two portraits are made all the more immediate by the matching costume and hairstyles in each, which in Millais's painting are fashionable dresses of the 1870s, inspired by the 1770s and 1780s. Interestingly, Walter Armstrong, the brother of the sit-ters, claimed that Millais had selected the dresses.

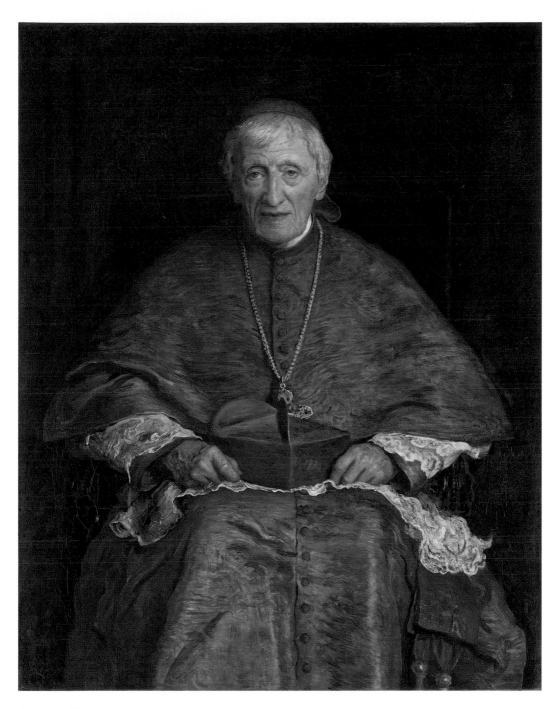

42  *Cardinal John*
*Henry Newman* 1881
Oil on canvas
121.3 × 95.3
(47¾ × 37½)
National Portrait
Gallery, London

Above
43  *Hearts are Trumps* 1872
Oil on canvas
165.7 × 219.7
(65¼ × 86½)
Tate

Left
44  Joshua Reynolds
*The Waldegrave Sisters* 1780–1
Oil on canvas
143.5 × 168
(56½ × 66⅛)
National Gallery of
Edinburgh

Millais's choice of model was wholly appropriate for another reason. Since the instigation of art exhibitions in the mid-eighteenth century, the duality of portraiture had necessarily meant the public 'display' of both the painting (as a work of art) and the sitter. The Waldegrave sisters were single women at the time Reynolds' portrait was exhibited at the Royal Academy in 1781. So were the Armstrong sisters. Both portraits can be understood as advertisements for their potential as wives, as the title *Hearts are Trumps* indicates. Millais's portrait is thus a complex fusion of ideas about viewing, both in terms of the painted surface and the display of the sisters as desirable marriage commodities to the viewing public, as well as the act of viewing itself. If Millais was modernising Velázquez, he was also modernising Reynolds.

Millais's experimentation with the Old Master tradition sometimes served the purpose of offering an aesthetic alternative to contemporary trends. For example, his resistance to classicism, which became established in the Royal Academy in the 1870s, was given visual expression in *The Knight Errant* in 1870. This was painted within a few years of what has been described as the 'renaissance' of the nude, signalled by Leighton's *Venus Disrobing for the Bath* 1866–7.[6] Through its subject and style, Leighton's painting emphasised the classical tradition and underlined the influence of the French artist, Jean-Auguste-Dominique Ingres, who was regarded internationally as the foremost practitioner of the classical nude. Ingres's *La Source* was exhibited in London and Paris in 1862 and 1867 respectively, and 'proved a revelation to

45  *The Knight Errant*
1870
Oil on canvas
184.1 × 135.3
(72 × 53¼)
Tate

English critics and painters'.[7] Such nudes were thought to demonstrate ideal beauty and thus quickly formed a distinct strand of the Aesthetic Movement. *The Knight Errant* can be viewed as a rebuttal to these trends and an attempt to revive a native tradition as previously represented by William Etty. The ever sympathetic F.G. Stephens observed in the *Athenaeum* that the flesh tones of Millais's nude were reminiscent of Titian. Of course, the Venetian artists (with Rubens) were models for Etty and British artists of the eighteenth century. And, interestingly, the juxtaposition of a dressed male and naked woman was a feature of, for example, Titian's *Perseus and Andromeda* (a rescue scene) and *Tarquin and Lucretia*, also known as *Rape of Lucretia (Tarquin and Lucretia)* (a rape scene). The medieval subject of *The Knight Errant* is distinctly unclassical and is essentially a chivalric subject invented by the artist, in the same vein as *Sir Isumbras*. But whereas *Sir Isumbras* was elegiac, *The Knight Errant* exudes tension, heightened by the energetic brushwork, corresponding with Titian's paintings previously mentioned. Unlike other artists, Millais did not often engage with medievalism. Thus the historical period and the insistence on a narrative made a loaded contrast between his nude figure and the subject-less classical nudes of, for example, Aestheticism. However, the trembling, fleshy realism of the female figure not only heightened the sense of her vulnerability (especially in juxtaposition with the hardness of the knight's armour), but clearly caused concern among critics on account of immodesty, prompting the idea that she was not entirely blameless for her predicament. This was exacerbated by her face being turned towards the knight in the original composition. The painting was thus viewed as ambiguous, if not dubious, unlike the purity and aloofness characteristic of the classical nude. Millais did not repeat the experiment.

## 'Hard, Hard Work'

Millais had produced portraits throughout his career. The earlier paintings tended to be private commissions from friends and close patrons, paralleled by portraits of his children in subject-paintings and fancy pictures. This continued alongside his successful commercial portrait practice and speculative canvasses of public figures. The financial rewards in the late nineteenth century were very high. For Millais, the 1870s saw portraiture become a major source of income, reaching a peak in about 1880. As with other genres, large sums of money could be made through portrait commissions or purchases from dealers for reproduction as engravings. The Fine Art Society bought Millais's portrait of Benjamin Disraeli (1881) for 1,400 guineas with copyright. As with *A Huguenot* and *The Black Brunswicker*, the *Disraeli* mezzotint was produced as a pendant to Millais's earlier portrait of William Gladstone.

Millais's oft-mentioned attractiveness and easy, charming manner were invaluable given the inevitable social demands made on the portrait painter during sittings. Millais was by this point a celebrity in his own right, and his new purpose-built studio-house in South Kensington was a practical demonstration of his great wealth and status. Completed in 1876, this imposing, palatial building was designed in the Italianate style. And in 1885, his eleva-

Opposite left
46 *Louise Jopling-Rowe* 1879
Oil on canvas
124.5 × 76 (49 × 30)
National Portrait Gallery, London

Opposite right
47 James McNeill Whistler
*Harmony in Flesh Colour and Black: Portrait of Louise Jopling* 1877
Oil on canvas
196.5 × 90 (75¾ × 55½)
Hunterian Art Gallery, University of Glasgow

tion to a baronetcy gave him a comparable social status to those he subsequently painted. By his own admission, however, the life of the professional portraitist was physically and mentally demanding. In a letter to Frank Holl, Millais noted that 'portrait painting is killing work to an artist who is sensitive, and he must be so to be successful.' Having finished four portraits in a row, he described the experience as 'hard, hard work'.[8] Clearly Millais's Pre-Raphaelite years had developed his natural (and highly marketable) ability to capture a likeness and the physicality of the sitter. His portrait of Elizabeth Siddal in *Ophelia* was, according to W.M. Rossetti, probably the best likeness ever made of her. In his *Art of Portrait Painting*, John Collier observed how Millais placed the sitter and canvas side by side, which had the advantage of 'immediate comparison' resulting in the 'vividness and life-likeness'.[9] This was the conclusion of the art critic, biographer and art-gallery director, Claude Phillips. 'Millais,' he wrote, 'gives us the whole man with mind and body in perfect balance, with breathe in his nostrils as well as speculation in his eyes.'[10]

Only perhaps in his portraits of children such as *Leisure Hours* and *Nina Lehmann*, which form part of the Aesthetic Movement, did Millais take an

intentionally generalised approach, in order to explore his own aesthetic ideas on beauty and childhood. However, traces of the Pre-Raphaelite refusal to idealise and flatter can be seen in his approach to adult portraiture. In contrast to James Sant and James Tissot, for example, Millais's portraits do not swagger, glamorise or linger over the details of contemporary fashion, but are marked by restrained poses and dignified expressions, which are characteristic from the portraits of Eliza Wyatt (1850) and John Ruskin (1853) onwards and later adapted through the example of Old Masters such as Velázquez and Rembrandt. Millais was not averse to painting contemporary dress, as his portraits of the Armstrong sisters and Mrs Bishoffsheim demonstrate. According to Louise Jopling, her highly fashionable, black silk costume with red trim was 'a dress that was universally admired'.[11] Made in Paris, it had a close-fitting cuirass bodice, a scalloped neckline with lace border, the underskirt, waistcoat and sleeves embroidered with flowers, with a floral bouquet at the breast. However, in the painting of Jopling, Millais has not painted a society portrait of a fashionable young woman. There is no flamboyance, coquettishness or theatricality. Jopling's own explanation of the portrait's development includes the comment that she had originally attempted a 'designedly beautiful expression' but, during conversation with Millais, had dropped her guard, at which point the artist, far more interested in her individuality, had painted her with hands clasped behind her back, looking with intelligence and confidence at the viewer.[12] Jopling was herself a portrait painter and a close friend, which may explain the sensitivity with which Millais responded to her.

Although the same sitter was often painted by a number of artists, it is possible that Millais's portrait of Jopling was yet another spirited riposte to Whistler, who had painted her two years earlier (fig.47). Both have plain backgrounds against which the outlines of the fashionably clad figure are delineated. But in contrast, Whistler subjugates personality and individuality to underline his aesthetic idea of paintings as arrangements of form and colour, accentuated by the flatness and abstraction of the figure and the back view with the head in profile. The viewer is thus largely drawn to the kind of elaborate back-drapery that was fashionable in the 1870s. Millais employed a similar pose for his portrait of Kate Perugini, exhibited at the Grosvenor Gallery in 1881. Perugini was the daughter of Charles Dickens and had previously modelled for Millais as the young woman in *The Black Brunswicker*. According to Perugini, also an artist, it was she who selected the pose. With broad brushstrokes, Millais suggests the form of the stylish, black dinner dress, replete with organza sleeves and neckline, but with a portrait in profile that is characterful and perceptive, even down to the variations in hair tone and the light reflected on the earring and eyelashes.

In her essay 'Why is Mr Millais our Popular Painter?', Emilie Isabel Barrington compared and contrasted the 'intellectual' and 'poetical' aspects of painting, as represented by her friend, G.F. Watts, with the 'unintellectual', 'realistic school' as represented by Millais. 'Very English, too,' Barrington observed, 'is the straightforward impression Mr. Millais' work gives'. This she characterised as 'an air of self-confident cheerfulness and satisfaction', executed by the artist with 'efficiency'.[13] Millais, it seems, did only enough on

48 *Kate Perugini*
1880
Oil on canvas
125.7 × 80
(49½ × 31½)
Private Collection

the canvas to get the job done. Would Barrington have made similar remarks about the bravura technique and subtle realism of Old Masters such as Velázquez, on whom Millais so clearly modelled himself? As we have seen, Millais's 'realistic art' cannot be dismissed as mere transcription. This is above all true of his highly innovative and poetic landscapes, executed from 1870 to within a few years of his death.

49 *The Sisters*
1855–7
Wood engraving by
the Brothers Dalziel
9.4 × 7.3 (3⅝ × 2⅞)
Published in *Poems*
*by Alfred Tennyson*,
Edward Moxon,
London, 1857
The British Museum,
London

## Poems in Painting

Even at the height of his success as a portrait painter in the late 1870s and
early 1880s, Millais continued to execute a full range of artistic genres, with
historical and religious paintings, contemporary life and fancy paintings and
what for Millais was a major departure in 1870, a series of large-scale land-
scapes, having executed only a handful of small-scale landscape canvasses
at the very beginning of his career and among his book illustrations of the
1850s and 1860s. Unlike the conventional landscape illustration to Anthony
Trollope's *Orley Farm* (1862), Millais's ability to lend a poetic mood to pure
landscape is underlined by the stark and atmospheric illustration that accom-
panied 'The Sisters', published in Edward Moxon's *Poetry of Alfred Tennyson*
(1857).

Millais's large-scale landscapes were based on various locations near his
Scottish home at Bowerswell in Perthshire and Burnham Hall nearby, which
he rented between 1881 and 1891. *Chill October* 1870 (fig.50) was the first of
these, exhibited at the Royal Academy in 1871. All these works reflect Millais's
personal response to Scotland, where he lived in the first years of his marriage
(Effie was Scottish) and to which he returned regularly to relax and indulge his
passion for field sports. Interestingly, contemporary commentators drew par-
allels between his recreational activities and Millais himself. In 1885, Walter
Armstrong thought he represented 'such a figure as we have come to associ-
ate rather with field sports and high farming than with the Arts'. And John
Underhill, in *Review of Reviews*, noted that his character had 'a freshness

which suggests the weather-clad moors of which he is so passionately fond'.[14] Millais had, of course, painted Scottish scenery in the portrait of Ruskin, *Autumn Leaves* and *Sir Isumbras*. The last two underline Millais's specific interest in the autumn season as a means of imbuing a painting with a poetic mood and feeling of transience. The later landscapes developed this emphasis on significance and feeling, but human figures, as in *Glen Birnam* 1891 (fig.51), no longer dominate the composition. This departure was noted by critics. Referring to *Chill October*, *The Times* observed that 'Mr. Millais has for the first time dispensed with figures altogether, and has made inanimate nature embody his feeling and tell his story'.[15]

Millais took up landscape painting when the genre was considered by many to be in crisis.[16] He may therefore have seized the opportunity (as with portraiture) to make his mark and develop an idiosyncratic response to national and international landscape trends. Ironically, it was mimetic realism as practised by Pre-Raphaelite artists that was primarily causing concern, because it was perceived as a style that stifled the imaginative power of the artist. Millais himself had participated in developing alternatives to Pre-Raphaelitism and kept abreast with other developments in the early 1860s and 1870s. The attention to light and effect in *Chill October*, for example, resembles the French Barbizon school. The wider focus on landscape at this point may have resulted from the staging of large-scale exhibitions, which contained works by leading practitioners of the past, including Thomas Gainsborough and John

50 *Chill October*
1870
Oil on canvas
141 × 186.7
(55½ × 73½)
Collection of Lord
Lloyd-Webber

51  *Glen Birnam*
1891
Oil on canvas
145.2 × 101.1
(57⅛ × 39¾)
Manchester Art
Gallery

Constable. The massive Turner Bequest, overseen by Ruskin, had begun to be exhibited at Marlborough House in 1858 and at the South Kensington Museum from 1859. Millais's ongoing engagement with these past British Masters can be seen in *Flowing to the River* 1871, which brings to mind paintings by Constable such as *The Hay Wain* 1821 and in *The moon is up, and yet it is not night* 1890, which, in composition and hazy atmospheric effects, is reminiscent of Turner.

If landscape was in crisis in 1870, Scottish landscape art was in danger of stagnating. Artists of the Romantic period had focused on the representation of the Highland region as an awe-inspiring wilderness. This was carried

forward into the reign of Queen Victoria who, from the 1840s, developed an intense but highly romanticised attachment to Scotland, and gave the royal stamp of approval to the perception among the English and Lowland social elites of Scotland as a sporting playground. Depictions of windswept landscapes by Millais and others encapsulated the isolation and engagement with (seemingly) unadulterated nature that was so appealing to city dwellers, Millais included, who considered it an antidote to the onslaught of industrialisation and the polluted, over-crowded urban experience. Millais's landscapes did, however, mark a distinct departure from Edwin Landseer's hauntingly fatalistic images of deer in a deserted landscape, painted between 1835 and 1866, as well as Horatio McCulloch's elegiac and ruggedly Romantic scenes, epitomised by *My Heart's in the Highlands* 1860. In Scotland, McCulloch was perceived as a national artist and his vision quickly achieved orthodoxy in the Scottish art establishment. From about 1870, Nonconformists, such as George Reid (an acquaintance of Millais), were pointedly selecting Lowland subjects and influences from, for example, contemporary Dutch and French realism, as a means of revitalising Scottish landscape art.

Like those of Reid and later the Glasgow Boys, Millais's landscapes do not follow the clichés of Romantic Highlandism and tartan-clad rusticity. Instead his landscapes conflate a gentle naturalism with compositions that were often distinctly un-'picturesque', as the word was understood by his contemporaries. *Chill October* is a view of a backwater on the River Tay, combining brown marsh grasses and swaying trees. In 1882, Millais wrote that he had chosen the subject 'for the sentiment it always conveyed to my mind ... although many of my friends at the time were at a loss to understand what I

52 Horatio
McCulloch
*My Heart's in the
Highlands* 1860
Oil on canvas
61 × 91.4 (24 × 36)
Glasgow Museums:
Art Gallery and
Museum,
Kelvingrove

saw to paint in such a scene'.[17] That Millais's landscapes challenged preconceived ideas about the genre is underlined by Sidney Colvin's opinion that *Chill October* was a 'new and eagerly-to-be-looked-for experiment'.[18] F.G. Stephens, writing in the *Athenaeum*, wholly understood Millais's intentions, describing the work as a 'noble and pathetic landscape' and, importantly, 'a poem in painting'.[19] Ruskin however viewed Millais's landscapes as uninspiring. Incidental scrubby undergrowth, marshy plateaux and overgrown gardens, as represented in, respectively, *Scotch Firs* 1873, *The Fringe of the Moor* 1874 and *The Deserted Garden* 1875 were not, to the critic's mind, the equivalent of majestic mountains. Ruskin was only one of a number of critics who were (wilfully?) blind to the poetical bias of Millais's landscapes, preferring to categorise them as transcriptions. 'Mr. Millais's idea of landscape,' noted a critic in the *Spectator*, 'appears, in short, to be confined to mere imitation'.[20]

As we have seen, Millais sometimes appended lines from poetry to his paintings. But it is likely that he did so with some landscapes, in order to elucidate his artistic intentions. Landscape amplified by excerpts from poetry was a conceit adopted during the late eighteenth century. Turner exhibited a large number of paintings with quotations from poetry, such as John Milton's *Paradise Lost* or Byron's *Childe Harold's Pilgrimage* or his own *Fallacies of Hope*. This affirmed the time-honoured notion that poetry and painting were complementary arts in their evocation of emotion through the description of the natural world, as summarised by Horace's famous phrase *ut pictura poesis*. Millais's *Winter Fuel* was shown at the Royal Academy in 1874, accompanied by the line 'Bare ruined choirs, where once the sweet birds sang', adapted from Shakespeare's Sonnet 73, the third of four poems that reflect on the onset of age in reference to autumn, an analogy after Millais's own heart. And the title *The moon is up, and yet it is not night* is, appropriately for a Turneresque landscape, a quotation from Byron's *Childe Harold's Pilgrimage* (Canto IV).

This poetic strategy culminated in *Dew-Drenched Furze* (fig.53), one of Millais's last landscapes, exhibited at the New Gallery in London in 1890. J.G. Millais emphasises the supernatural atmosphere of the painting, by describing his father as being compelled to produce the work by 'the potent voice of the wood spirits'. 'In the early morning,' he continued, 'the long grass bearded with dew lay at his feet, and all around were firs, bracken, and gorse bushes, festooned with silver webs, that showed a myriad diamonds glittering in the sun.' Millais's ambitions were undeniably high. As J.G. Millais wrote, he sought to create a 'scene such as had probably never been painted before, and might possibly prove to be unpaintable'.[21] With its inherent otherworldliness – generated by the misty morning light within a symmetrical composition and unusual vertical format – Millais's landscape is a highly imaginative, visionary response to nature. Indeed, *Dew-Drenched Furze* has been described as 'a wholly Symbolist nature study'.[22]

As with *Autumn Leaves*, the elegiac atmosphere of the painting is underscored by the title, which is derived from Tennyson's *In Memoriam* (1850), written after the early death of the poet's friend Arthur Hallam in 1833, at the age of twenty-two:

53 *Dew-Drenched Furze* c.1889–90
Oil on canvas
172 × 122
(67¾ × 48)
Geoffroy Richard Everett Millais Collection

Calm is the morn without a sound,
Calm as to suit a calmer grief,
And only thro' the faded leaf
The chestnut pattering to the ground:

Calm and deep peace on this high wold,
And on these dews that drench the furze,
And all the silvery gossamers
That twinkle into green and gold ...

Tennyson commented on the poem after publication, saying that 'different moods of sorrow as in a drama are dramatically given, and [the poem ultimately demonstrated] my conviction that fear, doubts, and suffering will find answer and relief only through Faith in a God of Love'. Albeit written after a personal tragedy, Tennyson insisted on the poem's universality, and said that the first-person narration was not always the author but 'the voice of the human race speaking through him'.[23] Millais's *Dew-Drenched Furze* offers 'a calmer grief' and confirmation of 'Faith in a God of Love', mentioned in Tennyson's poem. In this context, the painting represents perhaps a highly personal reflection on mourning by the artist, after the death in 1878 of his second son, George, at the age of just nineteen.

The critical response to *Dew-Drenched Furze* was mixed. M.H. Spielmann noted in the *Magazine of Art* that the landscape was 'well-nigh inexplicable in colour to him who has never witnessed at sunrise the play of light through the autumn-tinted bracken ... But the desired effect is marvellously reproduced, while the yellow-golden haze and russet-brown form a strange harmony, which grows upon the spectator'. *The Times* insisted, however, that the work 'has an interest as being an exact transcript of an actual scene in nature; but there is something wanting in it – the sparkle which Constable would have given it and the sense of something beyond which we find in Turner'.[24] If the polarised critical reaction to his innovative landscapes reflected reactions more generally, then Millais's contradictory attitudes towards public opinion, quoted at the beginning of this book, were understandable. But these responses also underline that aspects of Millais's work, throughout his career, were as challenging and innovative to a contemporary audience as those executed during his Pre-Raphaelite period. And they indicate the essential qualities of the artist's entire oeuvre. As William Blake Richmond recounted to J.G. Millais in 1899:

United with a highly poetic instinct and a romantic spirit that I
have often compared to that of Keats, Millais had an abundance of
common-sense and a love of accuracy which might have injured his
poetical faculty if that had not been in the first place eminent.[25]

# Notes

## Introduction

1 Reprinted in John Guille Millais, *The Life and Letters of John Everett Millais, President of the Royal Academy*, London 1899, vol.1, p.445.

2 Marion Harry Spielmann, 'In Memoriam: Sir John Everett Millais, P.R.A.', *Magazine of Art*, vol.19, Sept. 1896 (supplement), p.xvi.

3 Alfred Lys Baldry, *Sir John Everett Millais: His Art and Influence*, London 1899, p.34.

4 Arthur Symons, 'The Lesson of Millais', *The Savoy, an Illustrated Monthly*, London, no.6, Oct. 1896, p.57.

5 John Ruskin, 'Preface' in A Gordon Crawford, *Notes on Some of the Principal Pictures of Sir John Everett Millais exhibited at the Grosvenor Gallery, 1886*, exh. cat., Grosvenor Gallery, London 1886, p.v.

6 Symons in *The Savoy* 1886, p.57.

7 Alan Bowness in Leslie Parris (ed.), *The Pre-Raphaelites*, exh. cat., Tate Gallery, London 1984, p.21.

8 Paul Barlow, 'Millais, Manet, Modernity', in David Peters Corbett and Lara Perry (eds.), *English Art 1860–1914: Modern Artists and Identity*, Manchester 2000, p.49.

9 Russell Ash, *Victorian Masters and Their Art*, London 1999, p.368.

10 Printed in M.H. Spielmann, *Millais and His Works*, Edinburgh and London 1898, p.18.

## Chapter One: Brothers in Art

1 Elizabeth Prettejohn, *The Art of the Pre-Raphaelites*, London 2000, p.40.

2 E.T. Cook and Alexander Wedderburn (eds.), *The Works of John Ruskin*, vol.12 (39 vols., London 1903–12), p.339.

3 Ibid., p.xxiii.

4 John Ruskin, *Pre-Raphaelitism*, London 1851, p.31.

5 Ruskin 1851, p.29.

6 Quoted in Leslie Parris (ed.), *The Pre-Raphaelites*, exh. cat., Tate Gallery, London 1984, p.109.

7 Quoted in ibid., p.85.

8 *Works of John Ruskin*, vol.14, p.22, p.23.

9 Ibid., p.56.

10 Ibid., p.107.

11 *Works of John Ruskin*, vol.29, p.160; ibid., vol.14, p.496.

12 A Gordon Crawford, *Notes on Some of the Principal Pictures exhibited at the Grosvenor Gallery, 1886*, exh. cat., Grosvenor Gallery, London 1886, pp.17, 29.

## Chapter Two: Beauty Without Subject

1 Quoted in Leslie Parris (ed.), *The Pre-Raphaelites*, exh. cat., Tate Gallery, London 1984, p.141; see also Malcolm Warner, 'John Everett Millais's "Autumn Leaves": "a picture full of beauty and without subject"' in Leslie Parris (ed.), *Pre-Raphaelite Papers*, London 1984, pp.126–42.

2 Quote in Warner 1984, p.139.

3 Ibid., p.127.

4 E.T. Cook and Alexander Wedderburn (eds.), *The Works of John Ruskin*, (39 vols., London 1903–12), vol.14, p.56; quoted in Warner 1984, p.128.

5 Quoted in Warner 1984, pp.137–8.

6 John Guille Millais, *The Life and Letters of John Everett Millais, President of the Royal Academy*, London 1899, vol.1, p.303.

7 Ibid., pp.328–9.

8 Ibid., p.329.

9 *Athenaeum*, 9 May 1857, p.602.

10 *The Times*, 13 May 1857, third notice.

11 Millais 1 1899, p.333.

12 *Works of John Ruskin*, vol.14, pp.212, 215, 216.

13 Millais 1 1899, p.339, pp.339–40.

14 Ibid., p.336.

15 *Fraser's Magazine*, vol.70, July 1864, p.68.

16 Elizabeth and Joseph Pennell, *The Life of James McNeill Whistler*, vol.1, London 1908, pp.76–7.

17 Quoted in Richard Dorment and Margaret Macdonald (eds.), *James McNeill Whistler*, exh. cat., Tate Gallery, London 1995, p.76.

18 *Gazette des Beaux-Arts*, 2nd series, vol.2, July 1869, p.45.

19 Quoted in Pennell 1908, vol.1, p.129.

20 Millais 1 1899, p.384.

21 Millais 2 1899, p.66.

22 Ibid., p.354.

## Chapter Three: Our Popular Painter

1 Emilie Isabel Barrington, 'Why is Mr. Millais our Popular Painter?', *Fortnightly Review*, vol.38, July 1882.

2 John Guille Millais, *The Life and Letters of John Everett Millais, President of the Royal Academy*, London 1899, vol.1, p.348.

3 *Art Journal*, vol.14, 1852, p.174.

4  M.H. Spielmann, *Millais and His Works*, Edinburgh and London 1898, p.34.

5  Joshua Reynolds, *Discourse on Art*, ed. Robert R. Wark, Yale University Press, repr.1988, p.57.

6  Millais 1 1899, p.148.

7  E.S. de Beer (ed.), *The Diary of John Evelyn*, vol.1, London 1955, p.58.

8  Millais 1 1899, p.277.

9  Philip Gilbert Hamerton, *The Reaction from Pre-Raphaelitism*, London 1864, reprinted in John Charles Ormond, *Victorian Painting: Essays and Reviews*, New York and London 1985, vol.3, pp.144–5.

10  Millais 1 1899, p.52.

11  Marie Corelli, *The Sorrows of Satan*, (1895), Oxford 1998, pp.80–1.

12  Quoted in Dianne Sachko Macleod, *Art and the Victorian Middle Class*, Cambridge 1996, p.342.

13  Elizabeth and Joseph Pennell, 'John Everett Millais, Painter and Illustrator', *Fortnightly Review*, vol.60, Sept. 1896, p.445.

14  Baldry quotes Millais from 'Thoughts on Our Art of To-day', first published in the *Magazine of Art*. A full printed version is included in Spielmann 1898, pp.13–18.

15  Alfred Lys Baldry, *Sir John Everett Millais: His Art and Influence*, 1899, p.67.

16  Quoted in Leslie Parris (ed.), *The Pre-Raphaelites*, exh. cat., Tate Gallery, London 1984, p.21.

17  Spielmann 1898, p.125.

18  Millais 2 1899, p.48.

19  Ibid., p.73.

## Chapter Four: Old Masters, New Directions

1  Quoted in Gary Tinterow and Geneviève Lacambre (eds.), *Manet/Velázquez: The French Taste for Spanish Painting*, The Metropolitan Museum of Art/Yale University Press 2003, p.3.

2  Paul Barlow, 'Millais, Manet, Modernity', in David Peters Corbett and Lara Perry (eds.), *English Art 1860–1914: Modern artists and identity*, Manchester 2000, p.62.

3  John Collier, *The Art of Portrait Painting*, London 1910, p.42.

4  *Athenaeum*, 29 April 1882, p.544.

5  John Guille Millais, *The Life and Letters of John Everett Millais, President of the Royal Academy*, London 1899, vol.2, p.39.

6  Alison Smith (ed.) *Exposed: The Victorian Nude*, exh. cat., Tate Britain, London 2001, p.88. For further discussion of Millais's *Knight Errant* and the nude in Victorian painting see Alison Smith, *The Victorian Nude: Sexuality, Morality and Art*, Manchester 1996, pp.147–58.

7  Smith 2001, p.90.

8  Quoted in Peter Funnell and Malcolm Warner (eds.), *Millais: Portraits*, exh. cat., National Portrait Gallery, London 1999, p.30.

9  Collier 1910, p.61.

10  Quoted in Funnell and Warner 1999, p.27.

11  Quoted in Margaret Macdonald et al., *Whistler, Women & Fashion*, exh. cat., The Frick Collection, New York, (Yale University Press, London and New Haven) 2003, p.38.

12  Quoted in Funnell and Warner 1999, p.188.

13  Emilie Isabel Barrington, 'Why is Mr. Millais our Popular Painter?', *Fortnightly Review*, vol.38, July 1882, p.64.

14  Walter Armstrong, 'Sir John Everett Millais, Royal Academician. His Life and Work', *Art Annual*, 1885, p.30; John Underhill, 'Character Sketch: Sir John Everett Millais, Bart., R.A.', *Review of Reviews*, vol.11, April 1895, p.324.

15  *The Times*, 29 April 1871, p.12.

16  See Anne Helmreich's discussion of Millais and contemporary landscape in 'Poetry in Nature: Millais's Pure Landscapes', *John Everett Millais: Beyond the Pre-Raphaelite Brotherhood*, (ed. Debra Mancoff), New Haven and London 1999, pp.149–80.

17  Millais 2 1899, p.29.

18  Sidney Colvin, 'English painters of the Present Day – John Everett Millais, R.A.' *Portfolio* 2, London 1872, p.6.

19  *Athenaeum*, 29 April 1871, p.531.

20  *Spectator*, 16 May 1874, p.12.

21  Millais 2 1899, p.210, pp.210–13.

22  Andrew Wilton and Robert Upstone, *The Age of Rossetti, Burne-Jones and Watts: Symbolism in Britain, 1860–1910*, exh. cat., Tate Gallery, London 1997, p.174.

23  Hallam Tennyson, *Alfred Lord Tennyson: A Memoir*, London 1897, vol.1, pp.304–5.

24  *Magazine of Art*, 1890, p.308; *The Times*, 1 May 1890, p.13.

25  Quoted in J.G. Millais, *The Life and Letters of John Everett Millais, President of the Royal Academy*, London 1899, vol.2, p.444.

# Bibliography

Alfred Lys Baldry, *Sir John Everett Millais: His Art and Influence*, London 1899.

Paul Barlow, 'Millais, Manet, Modernity', in David Peters Corbett and Lara Perry (eds.), *English Art 1860–1914: Modern Artists and Identity*, Manchester 2000.

Paul Barlow, *Time Present and Time Past: The Art of John Everett Millais*, London 2005.

Mary Bennett, *Artists of the Pre-Raphaelite Circle: The First Generation Catalogue of Works in the Walker Art Gallery, Lady Lever Art Gallery and Sudley Art Gallery*, London 1988.

Mary Bennett, *Millais PRB, PRA*, exh. cat., Walker Art Gallery, Liverpool, and Royal Academy, London 1967.

E.T. Cook and Alexander Wedderburn (eds.), *The Works of John Ruskin*, 39 vols., London 1903–12.

Claire Donovan and Joanne Bushnell, *John Everett Millais 1829–1896: A Centenary Exhibition*, exh. cat., Southampton Institute, Southampton 1996.

Gordon H. Fleming, *John Everett Millais: A Biography*, London 1998.

Peter Funnell and Malcolm Warner (eds.), *Millais: Portraits*, exh. cat., National Portrait Gallery, London 1999.

Patricia Bradshaw Gamon, '"Millais's Luck": A Pre-Raphaelite's Quest for Success in the Victorian Painting and Print Market, 1848–1863', 2 vols., Ph.D. diss., Stanford University, Stanford 1991.

Paul Goldman, *Victorian Illustrated Books 1850–1870: The Heyday of Wood-Engraving*, London 1994.

Paul Goldman and Tessa Sidey, *John Everett Millais: Illustrator and Narrator*, London 2004.

William Holman Hunt, *Pre-Raphaelitism and the Pre-Raphaelite Brotherhood*, 2 vols., London and New York 1905.

Debra N Mancoff (ed.), *John Everett Millais: Beyond the Pre-Raphaelite Brotherhood*, New Haven and London 1999.

John Guille Millais, *The Life and Letters of John Everett Millais, President of the Royal Academy*, 2 vols., London 1899.

Leslie Parris (ed.), *The Pre-Raphaelites*, exh. cat., Tate Gallery, London 1984.

Elizabeth Prettejohn, *The Art of the Pre-Raphaelites*, London 2000.

Dianne Sachko Macleod, *Art and the Victorian Middle Class*, Cambridge 1996.

Christine Riding, 'Old Masters and Edwardian Society Portraiture' in Anne Gray, *The Edwardians: Secrets and Desires*, exh. cat., National Gallery of Australia, Canberra 2004.

Marion Harry Spielmann, 'In Memoriam: Sir John Everett Millais, P.R.A.', *Magazine of Art*, vol.19, Sept. 1896 (supplement).

Marion Harry Spielmann, *Millais and His Works*, Edinburgh and London 1898.

Allen Staley, *The Pre-Raphaelite Landscape*, Oxford 1973.

Allen Staley and Christopher Newall, *Pre-Raphaelite Vision: Truth to Nature*, exh. cat., Tate Britain, London 2004.

Malcolm Warner, *The Drawings of John Everett Millais*, exh. cat., Bolton Museum and Art Gallery/Arts Council of Great Britain 1979.

## Photographic Credits

Unless otherwise stated, photographic copyright is as given in the figure caption to each illustration.

The Bridgeman Art Library 25, 30, 32, 35, 36, 37, 48, 59

©1988 The Detroit University of Arts 54

Scala, Florence – courtesy of the Ministero Beni e Att. Culturali 4

Sotheby's Picture Library 25

# Index